Dogs just wanna have FUN!

Cheryl Murphy

PICTURE THIS: DOGS AT PLAY

Foreword by Andy Biggar, The Dog Photographer

Hubble & Hattie

The Hubble & Hattie imprint was launched in 2009, and is named in memory of two very special Westie sisters owned by Veloce's proprietors. Since the first book, many more have been added, all with the same objective: to be of real benefit to the species they cover; at the same time promoting compassion, understanding and respect between all animals (including human ones!) All Hubble & Hattie publications offer ethical, high quality content and presentation, plus great value for money.

More great books from Hubble & Hattie –

www.hubbleandhattie.com

First published May 2018 by Veloce Publishing Limited, Veloce House, Parkway Farm Business Park, Middle Farm Way, Poundbury, Dorchester, Dorset, DT1 3AR, England. Tel 01305 260068/Fax 01305 250479/email info@hubbleandhattie.com/web www.hubbleandhattie.com ISBN: 978-1-787112-01-8 UPC: 6-36847-01201-4

Contents

Acknowledgements

Many people have helped this book become a reality, starting with the suggestion from Katherine Sarluis that I turn my photographs of dogs enjoying themselves into a book. Thank you, Katherine, for encouraging me to capture, through the eyes of a lens, the wonderful expressions of dogs playing and having fun.

I would have struggled without the co-operation of the dog owners who have allowed me to photograph their dogs, and given me permission to use the images in this book. A big thank you to all of them.

Special thanks should go to Christine Harrod for all her help with this book. I received help from many others, too, and would especially like to thank Bev Bethell, Caroline Byrne, Ian O'Neill, Paula Harcome, Flick Berry, and Natalijia Micunovic for last-minute help.

My own dogs have played an important part, of course: without Tilly, Ruby and Nellie I would not have encountered so many dogs willing to play and provide photographic opportunities.

Many people have provided help and support in this venture, and I appreciate every contribution and suggestion made.

Cheryl Murphy
Beverley
East Yorkshire

Foreword

Dogs are certainly all about fun, and whatever life throws at them, they just get on with it, seek out their nearest toy and want to play and have fun.

Capturing dogs on film during play is not easy, as they very rarely run in a straight line, or stay still for long, preferring to be racing around at a hundred miles an hour, which can make it very tricky for a photographer.

Cheryl has done a great job capturing the real characters of the dogs in this book, which is certainly no mean feat. Its great to see a collection of images like this of Man's Best Friend really showing us how to have fun!

Well done!

Andy Biggar
The Dog Photographer

Introduction

A great many books have been published celebrating dogs. Some show the strong bond between dogs and people, some demonstrate how well trained they can be and others are a catalogue of doggie attire and accessories.

But there are very few that celebrate dogs simply being themselves, enjoying – and delighting in – natural behaviour unencumbered by cues or clothing. This book is intended to showcase dogs following their natural instincts, displaying their individual characteristics, and, most importantly, having fun!

Animals have been a part of my life from childhood, with family dogs and cats succeeded by horses in early adulthood. Golden Retrievers have been my choice of canine for the last twenty years. Sadly, my three generations of Retrievers have died, but their successors, Ruby and her daughter, Nellie, carry on the golden tradition of individual personalities.

All five of my 'Goldens' have had vastly differing characters. Tess adored people and loved unreservedly … until something needed chasing, whereupon she became totally deaf, and disappeared for hours on end. Her daughter, Chloe, ate anything and everything, patiently lying under the bird table waiting for crumbs, and once famously consuming an entire tub of yeast vitamin tablets.

Tilly, Chloe's daughter, was the inspiration for this book. A law unto herself, Tilly loved everyone under the age of ten, and even some above it – but only if she felt so inclined. Tilly was the most stubborn and opinionated dog I have ever known, with no desire to do anything to please any except her chosen few. Tilly's approval was hard-won … and all the more precious for its exclusivity.

Ruby joined us five years ago, and is known as Roo after her chosen and much-repeated form of greeting – 'roo, roo, roo.' A natural poseur, she has featured in *One Magazine*, and promotional material for snuffle mats.

Nellie is Ruby's daughter, and is also known as Noodle as she is as flexible as a piece of cooked pasta. Just when we thought our dogs could not be more affectionate, Nellie proved otherwise. She loves everyone unconditionally, treating one and all to her special brand of ear- and nose-licking.

I cannot imagine life without my canine family members. My mother-in-law was once asked which animal she would like to come back as in another life, and her answer of "One of Cheryl's dogs" is testimony to just how much my dogs are an integral part of my family.

Ruby and Nellie have special starring roles in this book as it was their interaction with other dogs that made possible many of these uninhibited shots. They happily participated, or observed, in various canine pursuits, from ball-chasing and mud-wallowing, to swimming and rolling.

Our dogs have such diverse and individual personalities that the owners of those featured here were hard-pressed to limit their descriptions of their beloved companions to just a few words in the *Meet the Cast* chapter. In the compilation of this book, it is the owners who are the unsung heroes: sufficiently confident that their dogs will recall as necessary, and happy to let their companions run free and interact with other dogs, safe in the knowledge that hair will dry, mud can be hosed off, and towels can be washed – and even the scent of fox poo can be eradicated ... eventually.

Join us in a true celebration of what it is to be a dog: after all, dogs just wanna have fun!

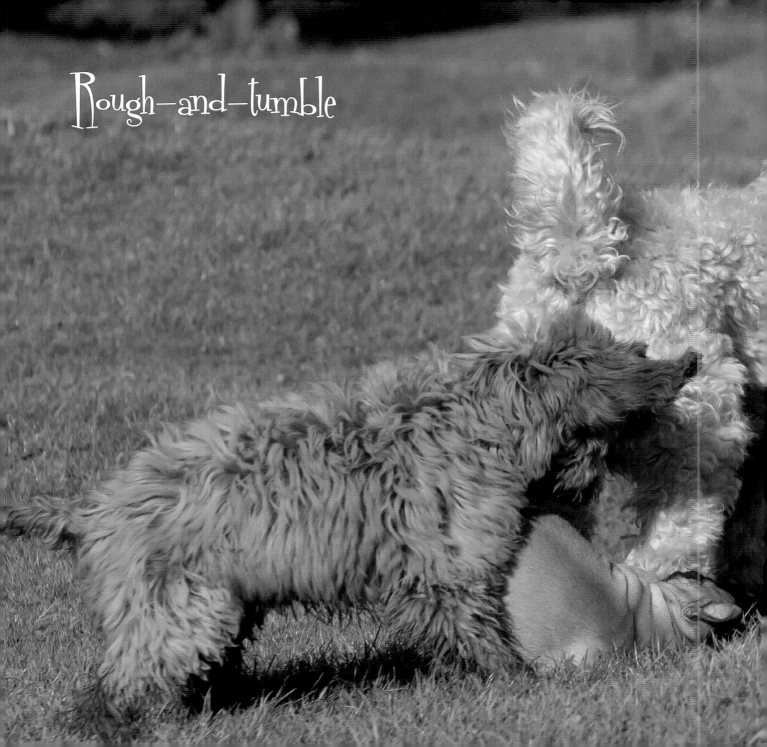

Rough-and-tumble

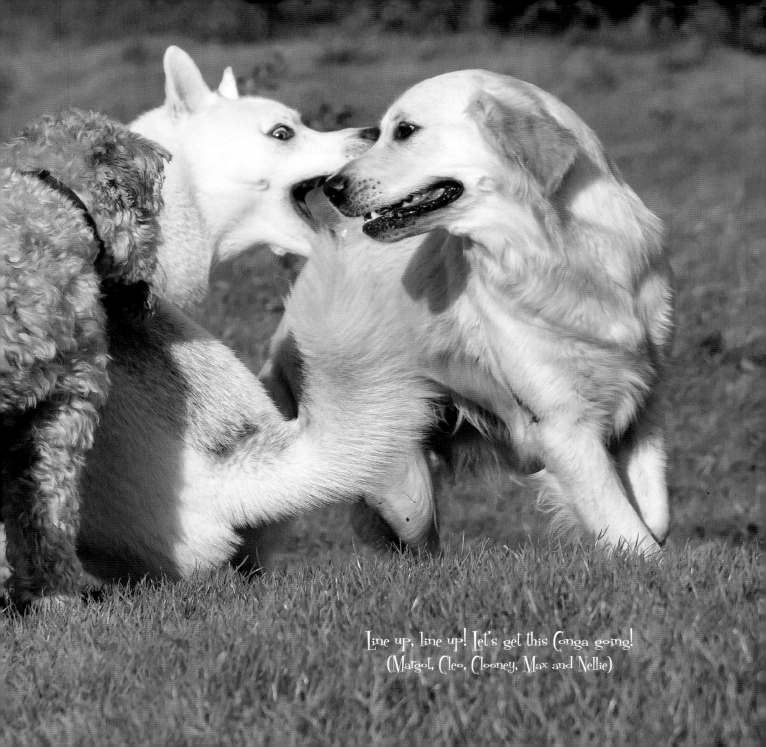

Line up, line up! Let's get this Conga going!
(Margot, Cleo, Clooney, Max and Nellie)

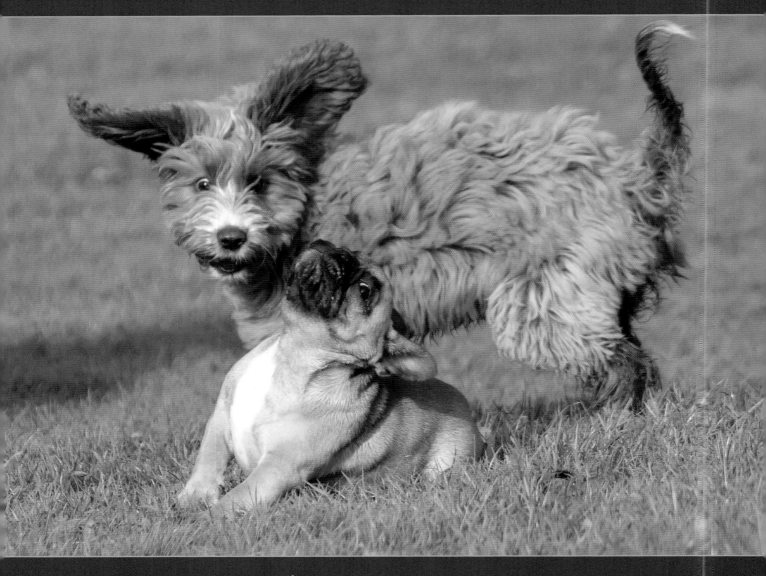

My! What big ears you have ...
(Margot and Cleo)

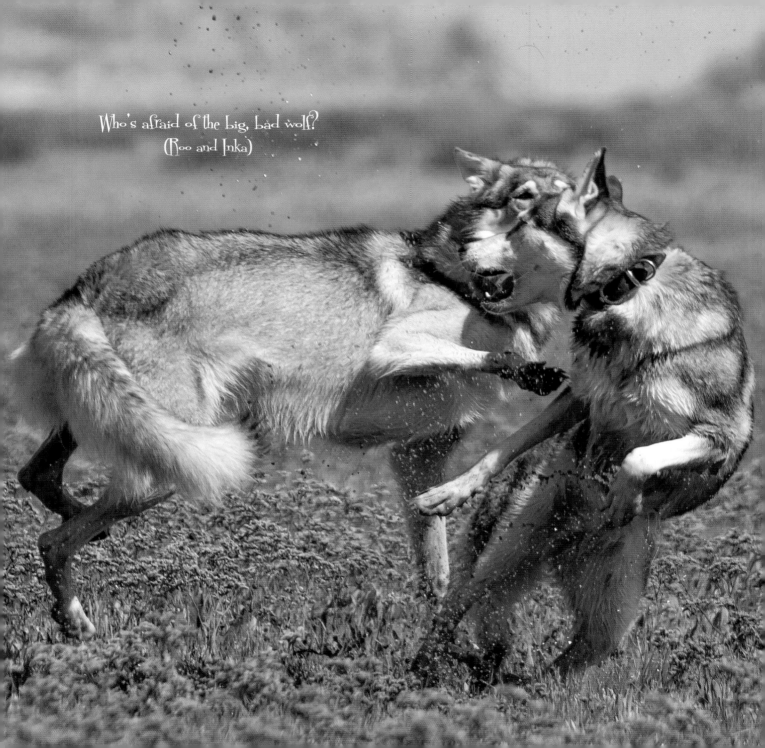

Who's afraid of the big, bad wolf?
(Roo and Inka)

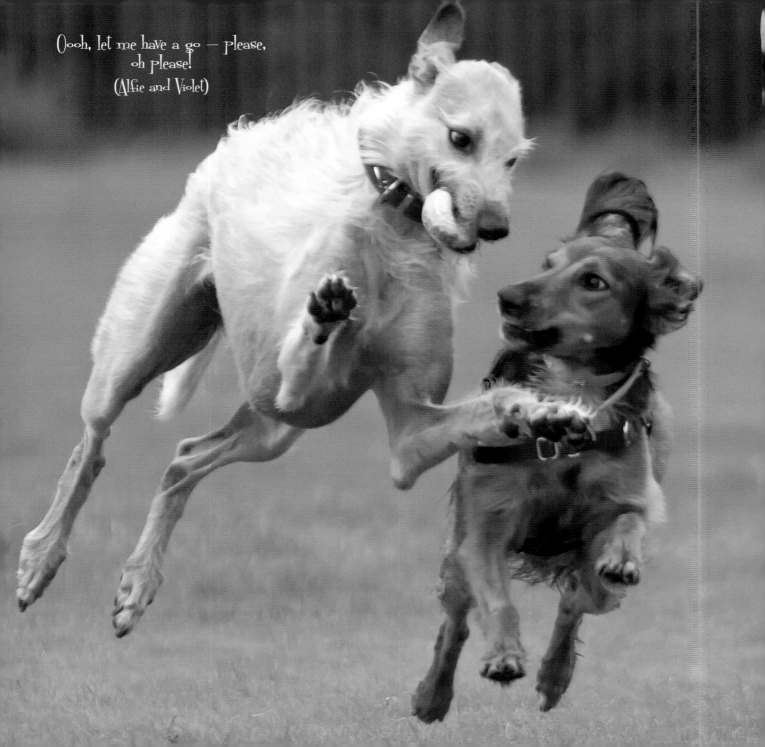

Oooh, let me have a go — please,
oh please!
(Alfie and Violet)

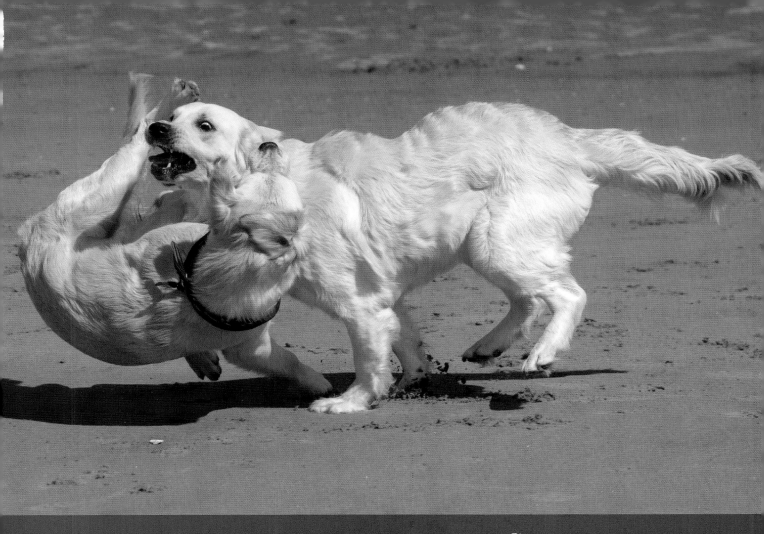

Whoa! What's happened to your brakes?!
(Nellie and Lottie)

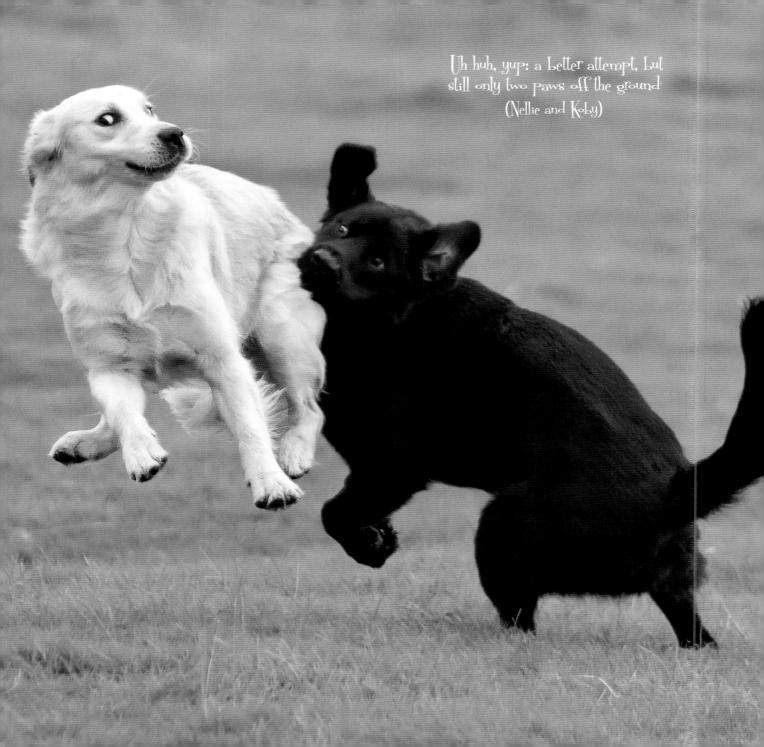

Uh huh, yup: a better attempt, but still only two paws off the ground (Nellie and Koby)

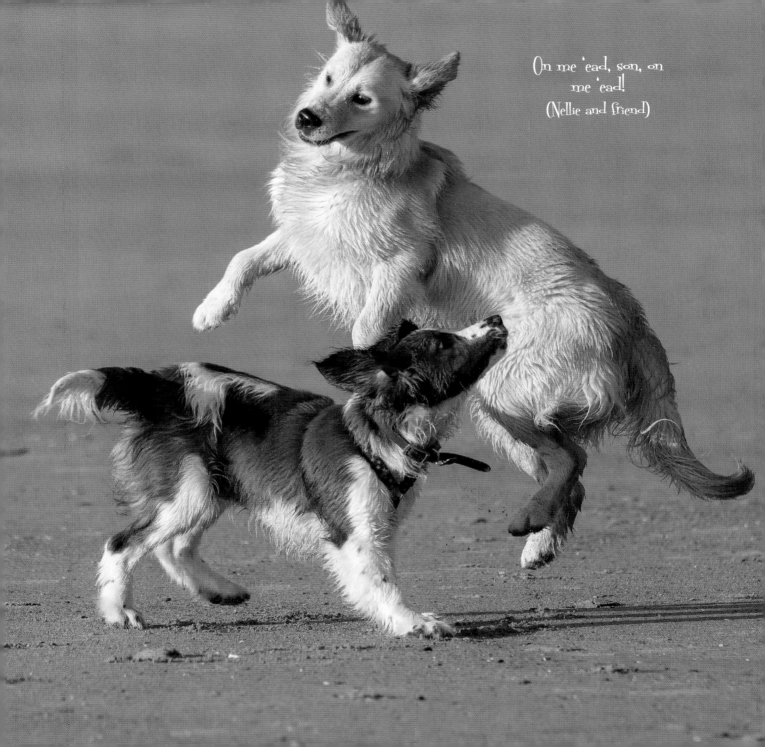

On me 'ead, son, on me 'ead!
(Nellie and friend)

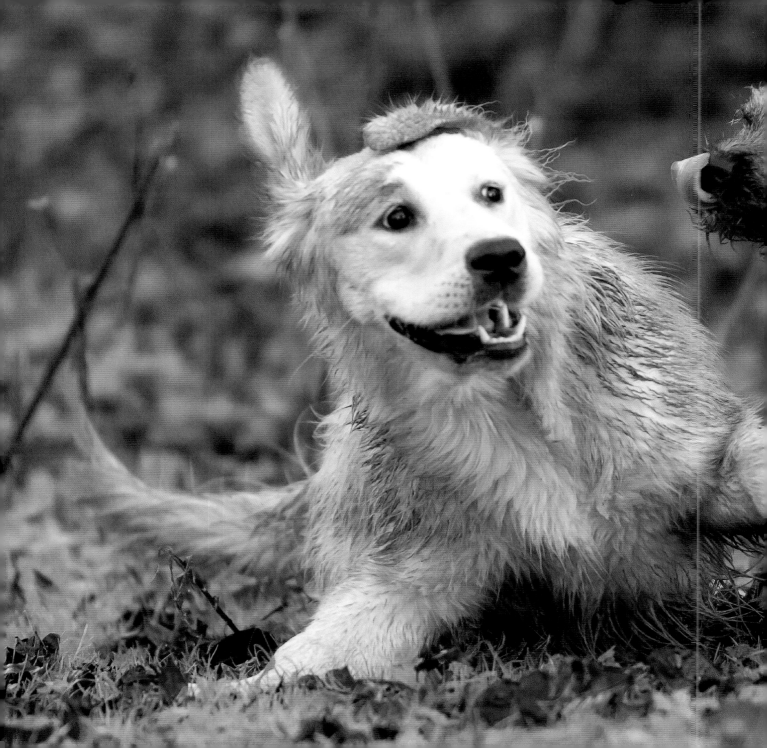

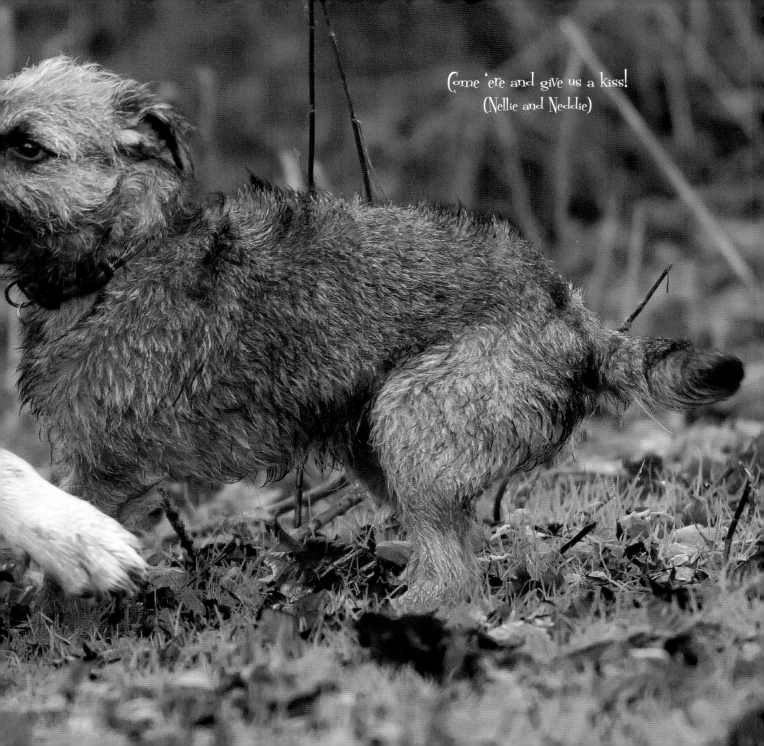

Come 'ere and give us a kiss!
(Nellie and Neddie)

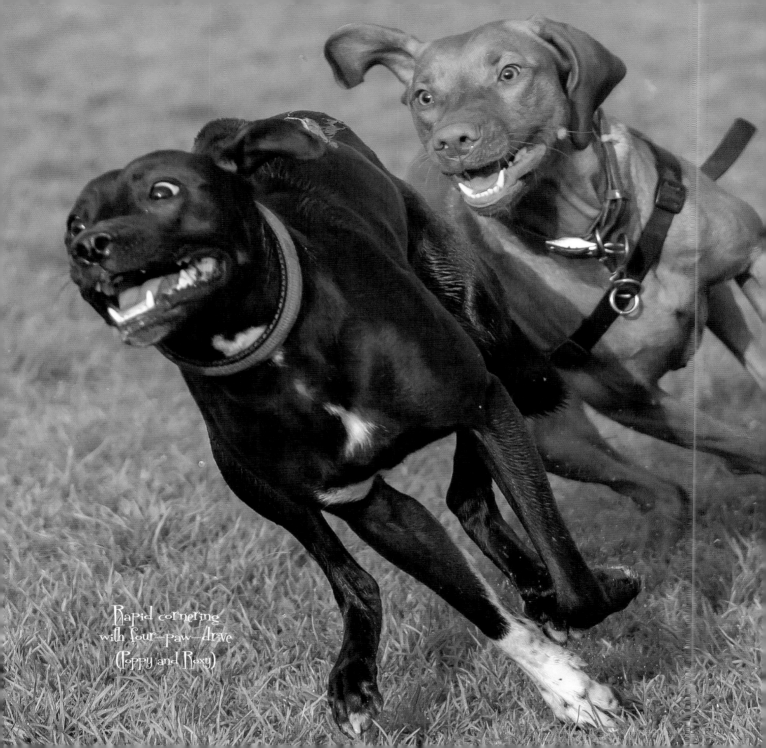

Rapid cornering
with four-paw-drive
(Poppy and Roxy)

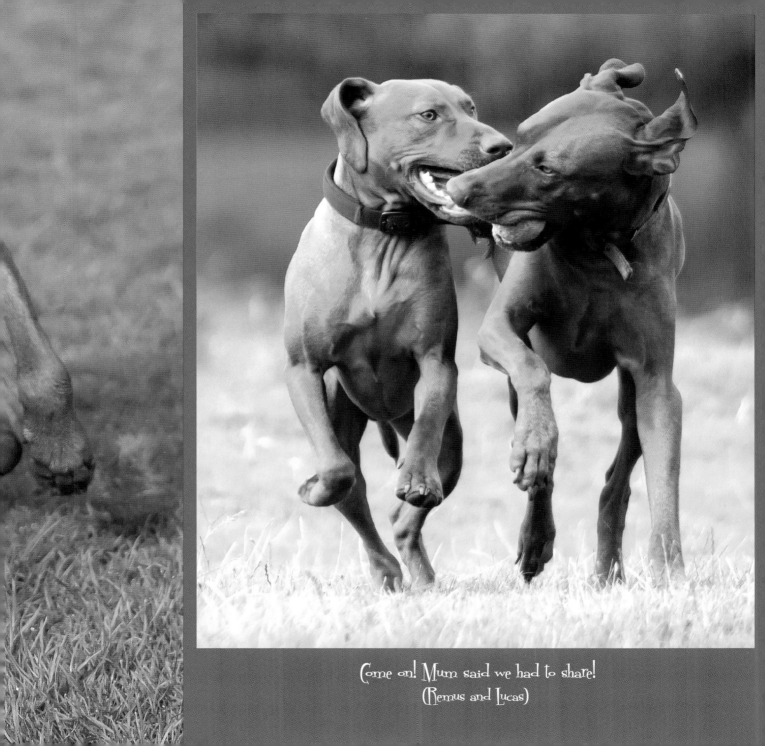

Come on! Mum said we had to share!
(Remus and Lucas)

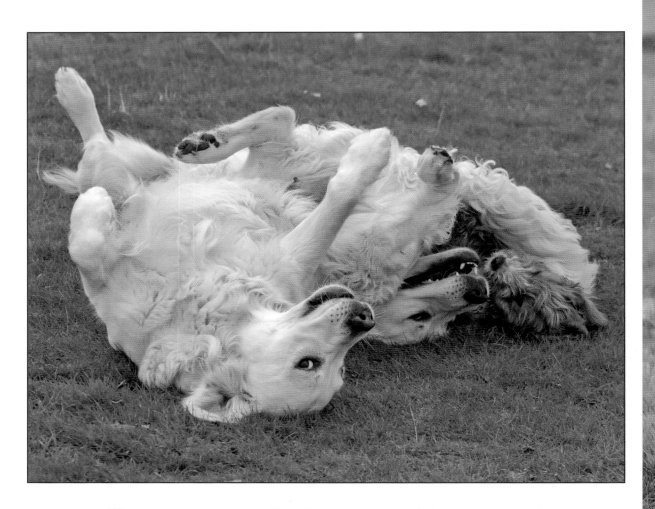

There were three in the bed, and the little one said: 'roll over, roll over'
(Ruby, Nellie and Margot)

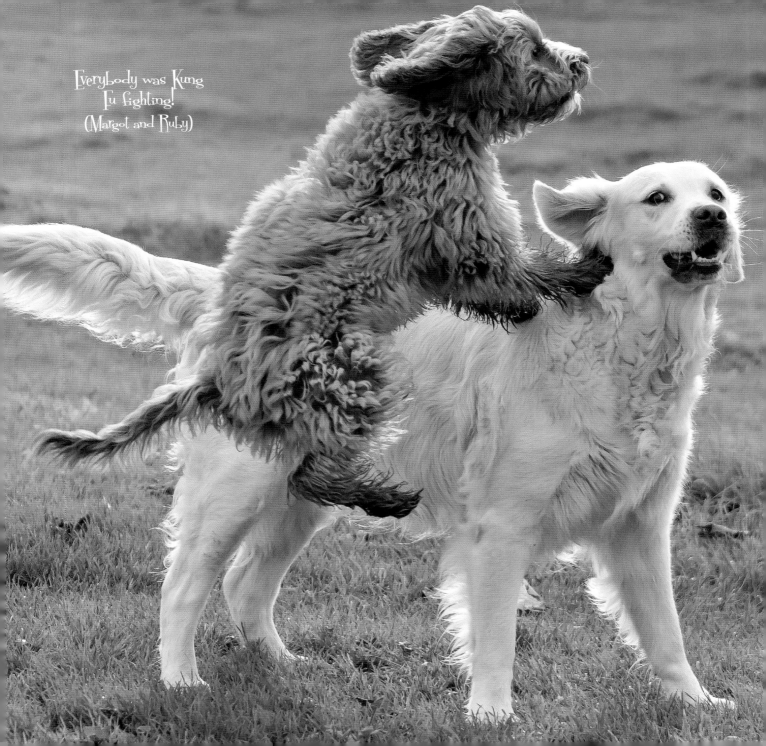

Everybody was Kung
Fu fighting!
(Margot and Ruby)

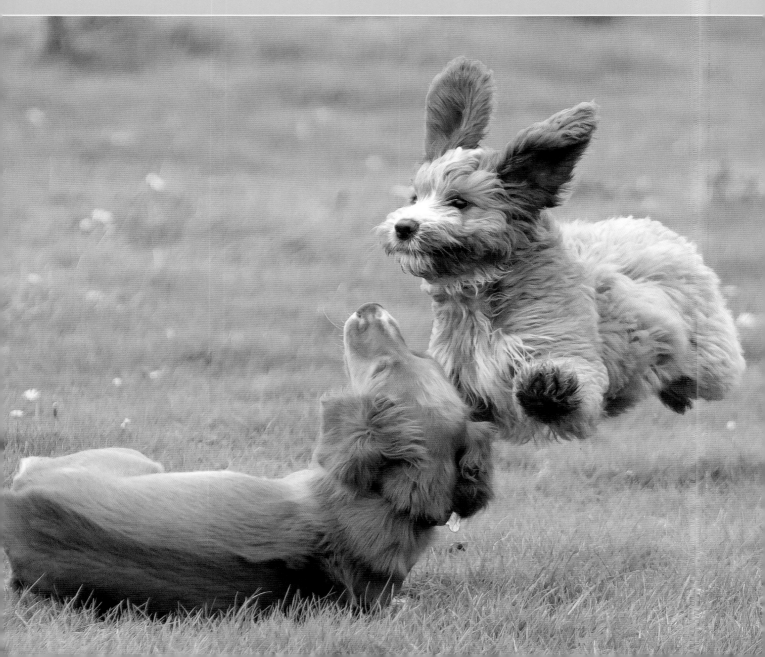
I thought you were a Cockapoo, not an AIR-dale!
(Molly and Margot)

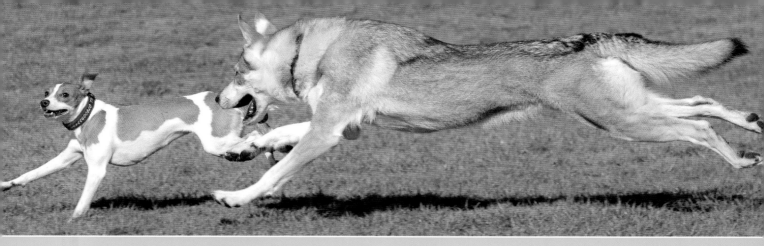

Best foot forward, and s–t–r–e–t–c–h!
(Diva and friend)

Would you just get off my back?!
(Ruby and Dexter)

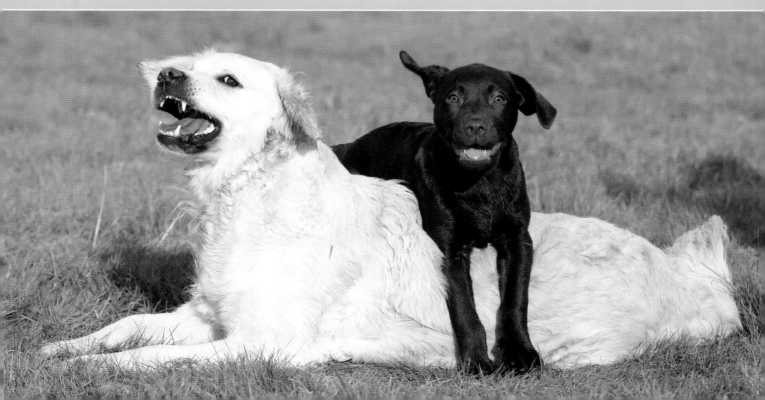

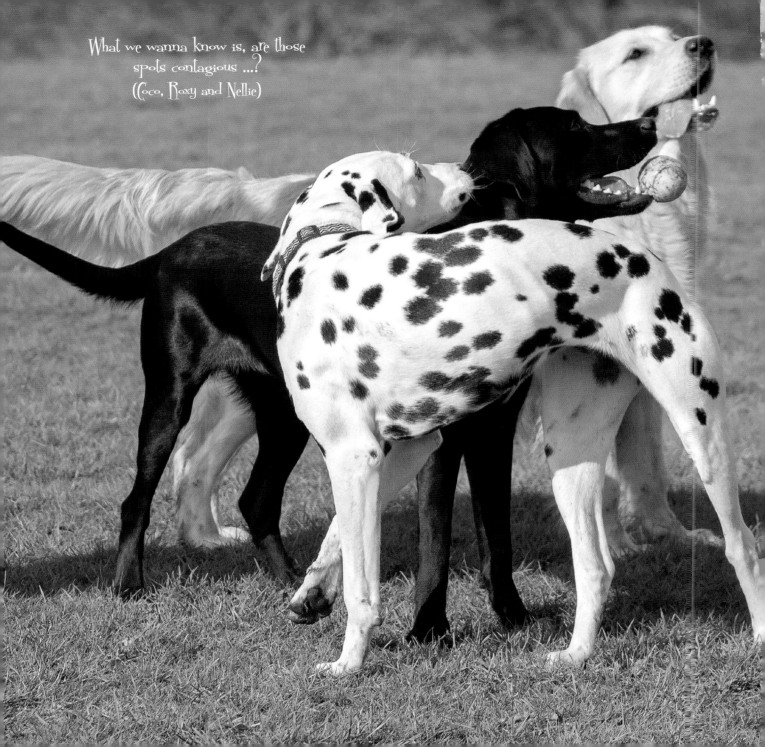

What we wanna know is, are those
spots contagious ...?
(Coco, Roxy and Nellie)

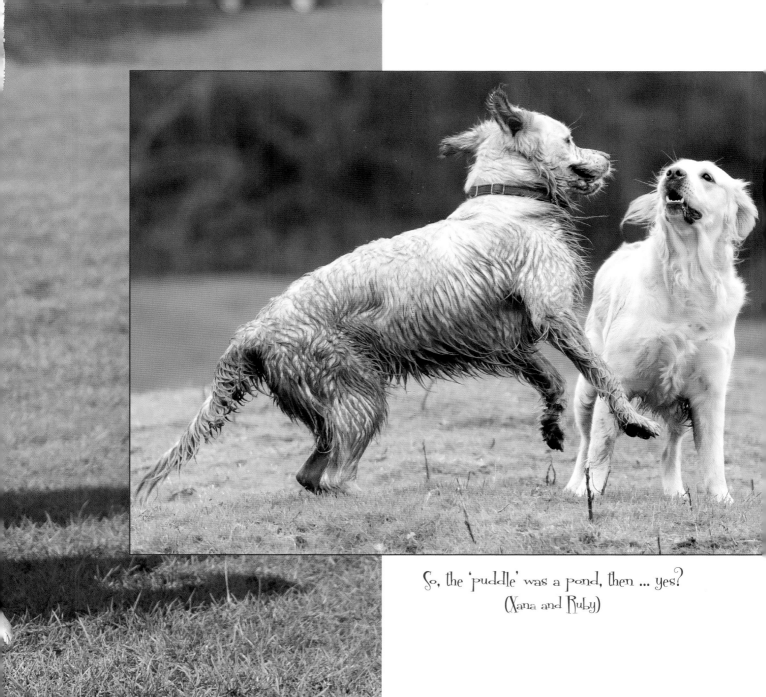

So, the 'puddle' was a pond, then ... yes?
(Xana and Ruby)

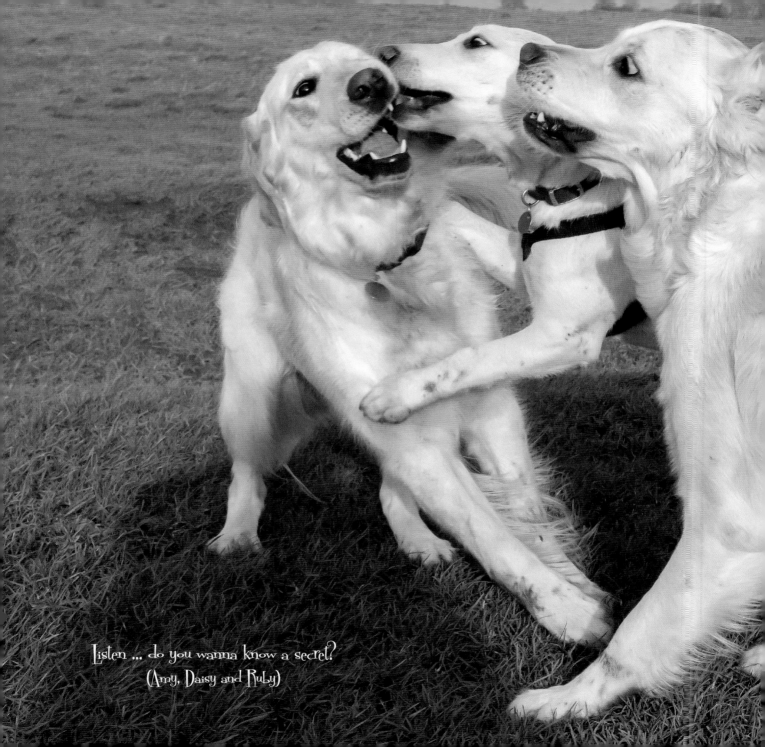

Listen ... do you wanna know a secret?
(Amy, Daisy and Ruby)

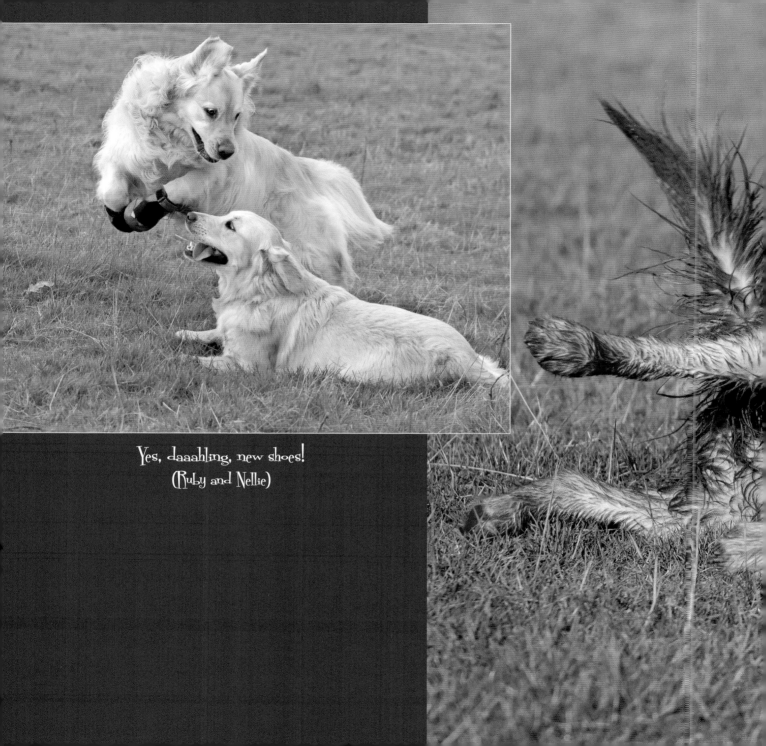

Yes, daaahling, new shoes!
(Ruby and Nellie)

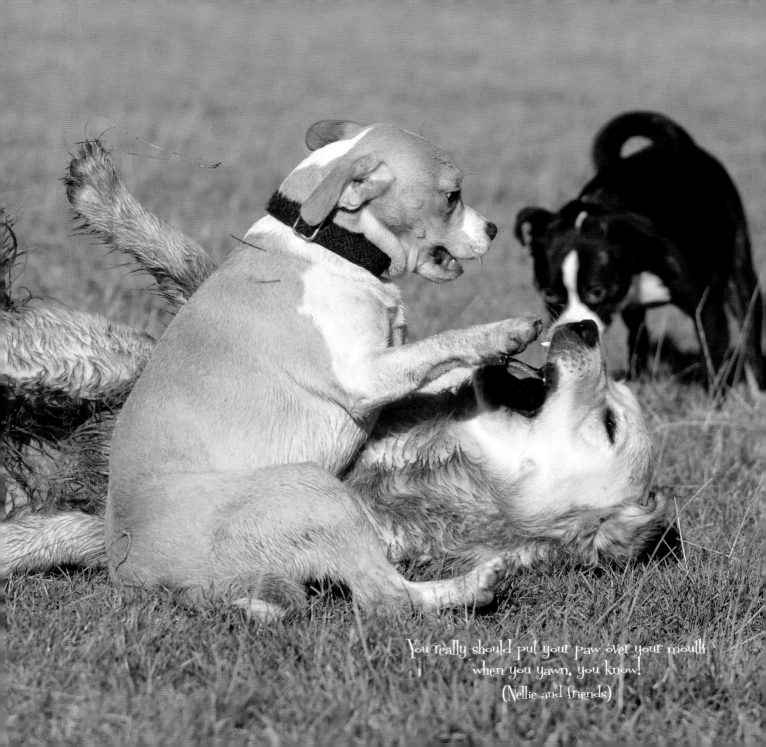

You really should put your paw over your mouth when you yawn, you know! (Nellie and friends)

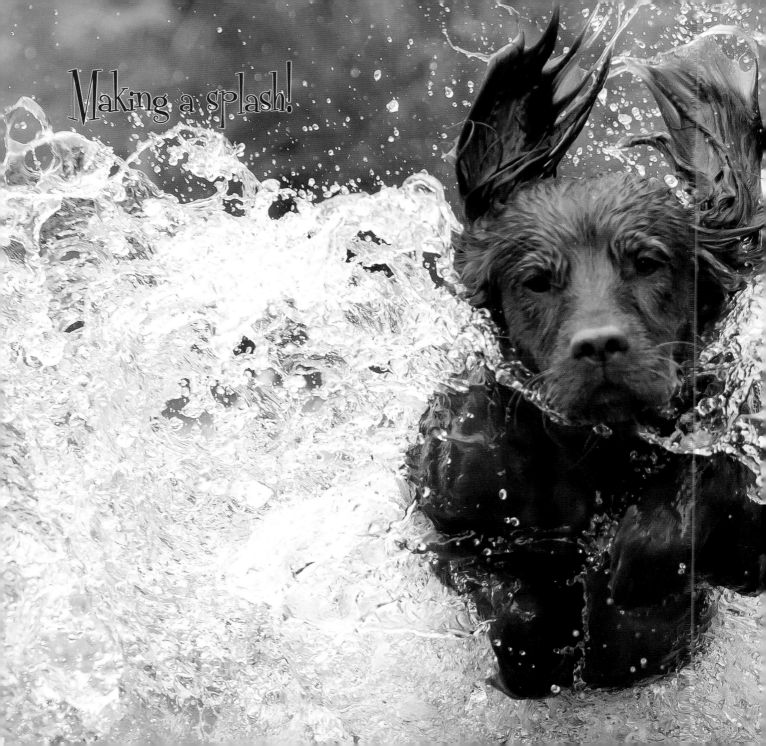

Making a splash!

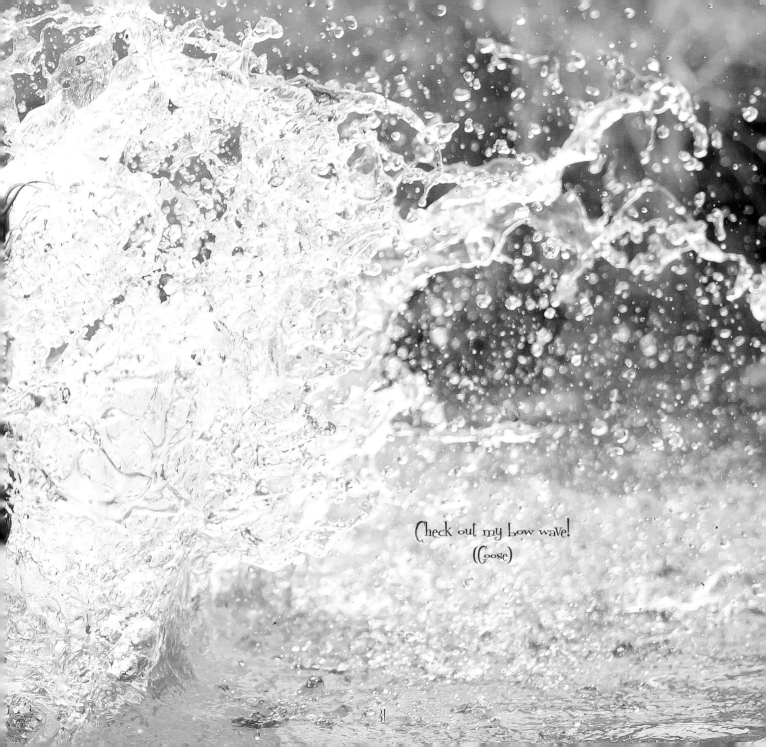

Check out my bow wave!

(Goose)

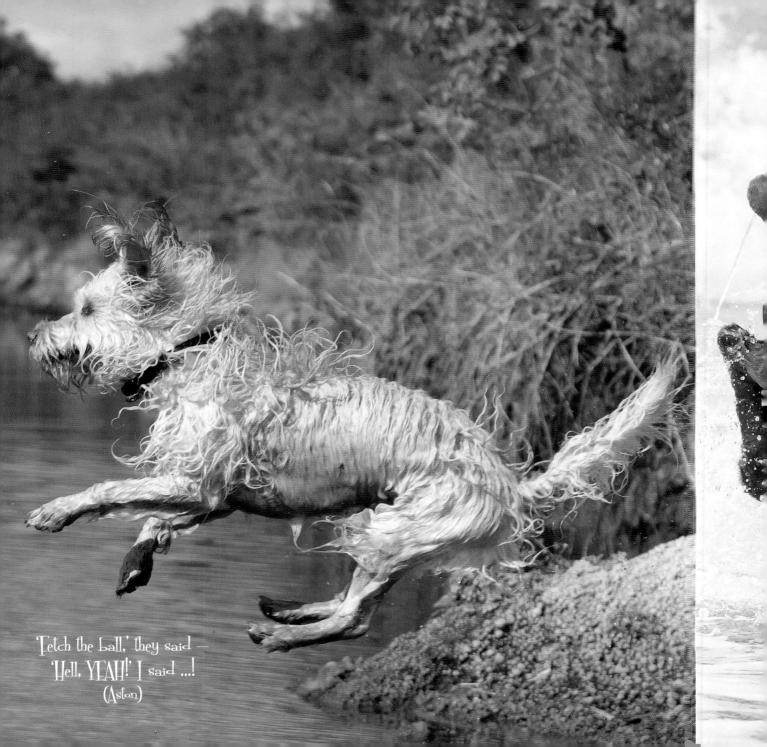

'Fetch the ball,' they said —
'Hell, YEAH!' I said ...!
(Aston)

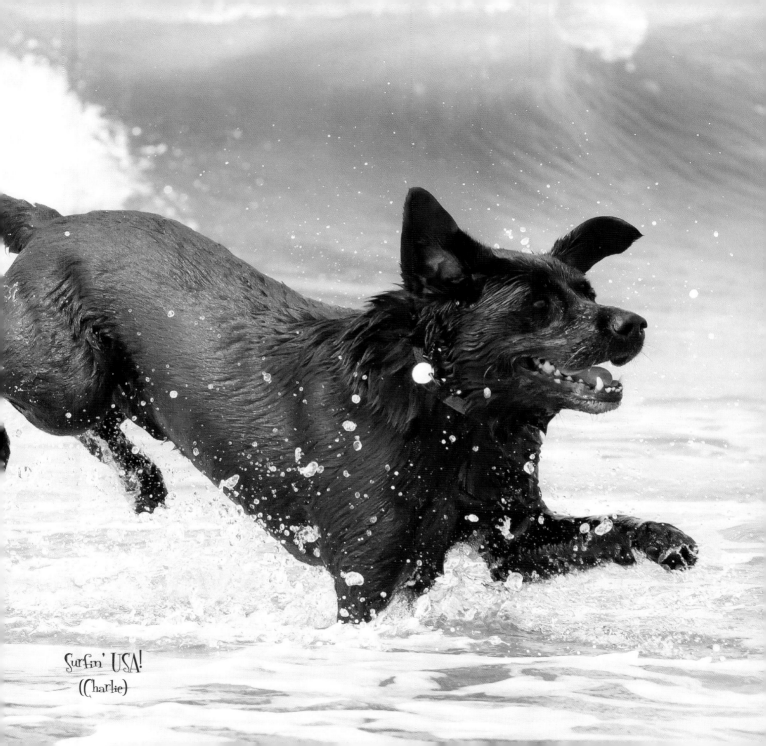

Surfin' USA!
(Charlie)

I wonder how deep this is in the middle ...?
(Poppy)

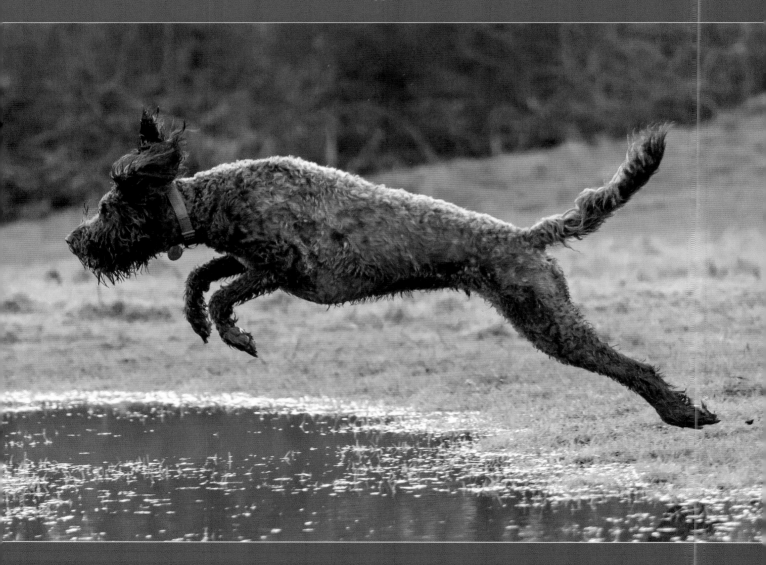

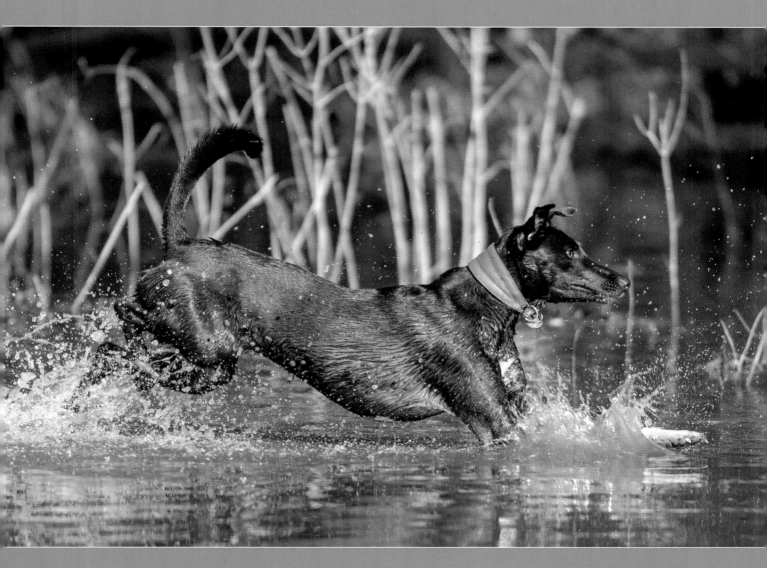

Not quite got the hang of this walking on water lark ...
(Blue)

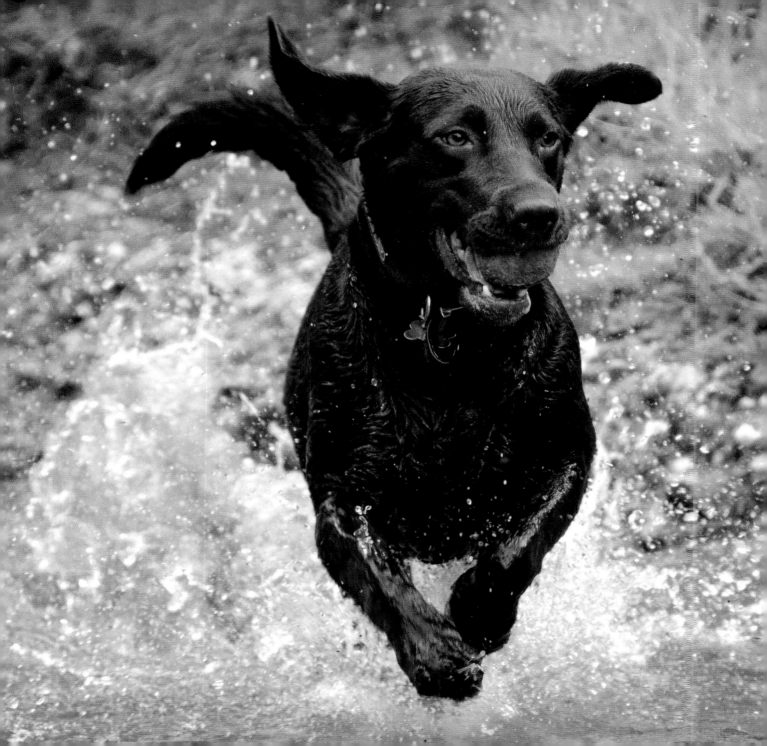

Who needs four-
wheel-drive?
(Meg)

This is the last time I'm going
in to get this for you!
(Goose)

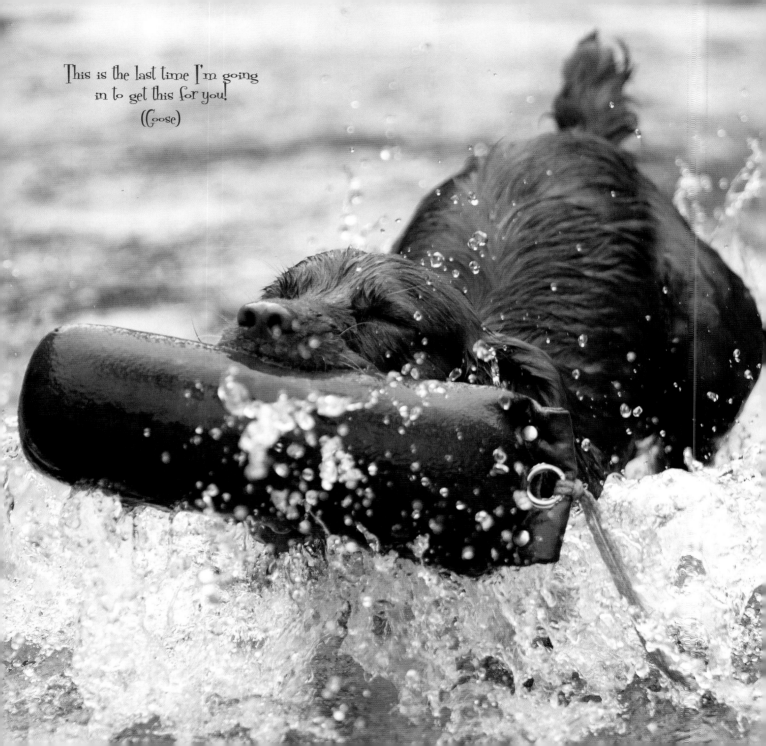

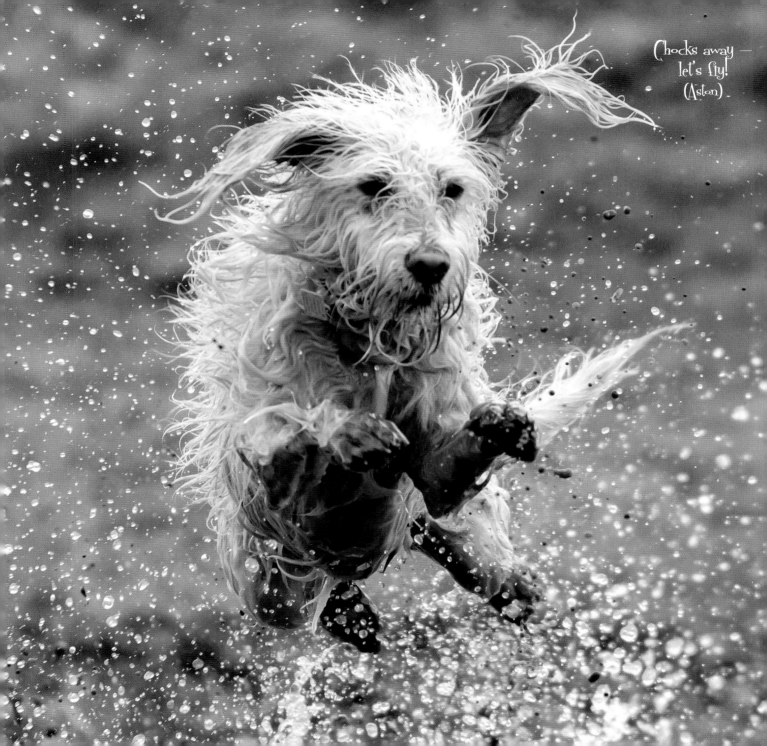

Chocks away —
let's fly!
(Aston)

Who needs a jet-ski
when you can have a
pet-ski?!
(Blue)

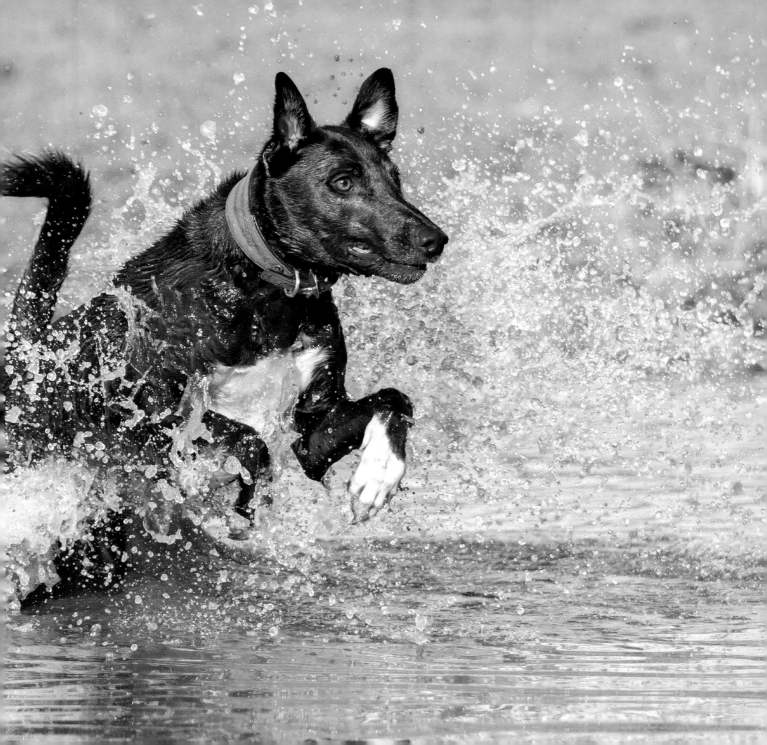

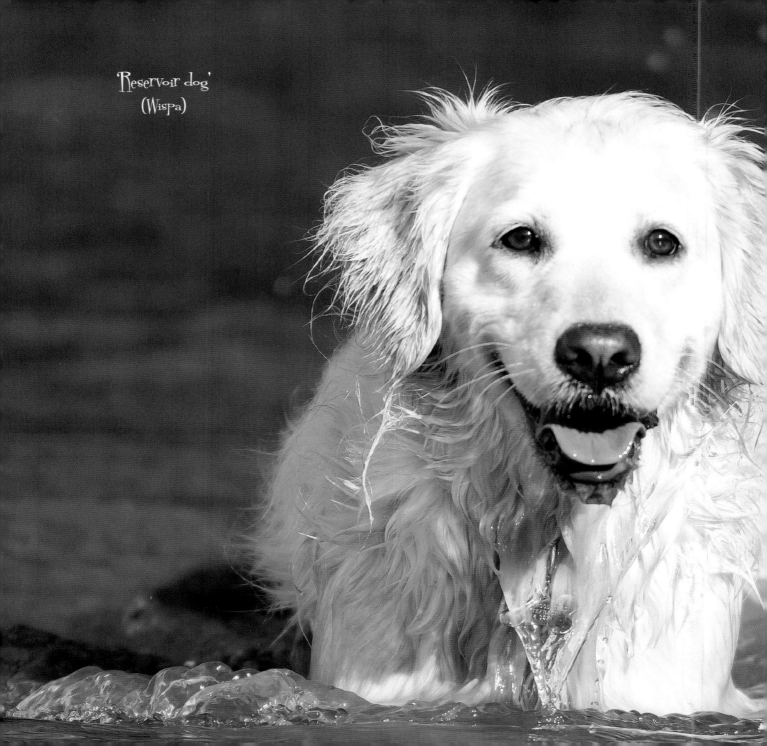

'Reservoir dog'
(Wispa)

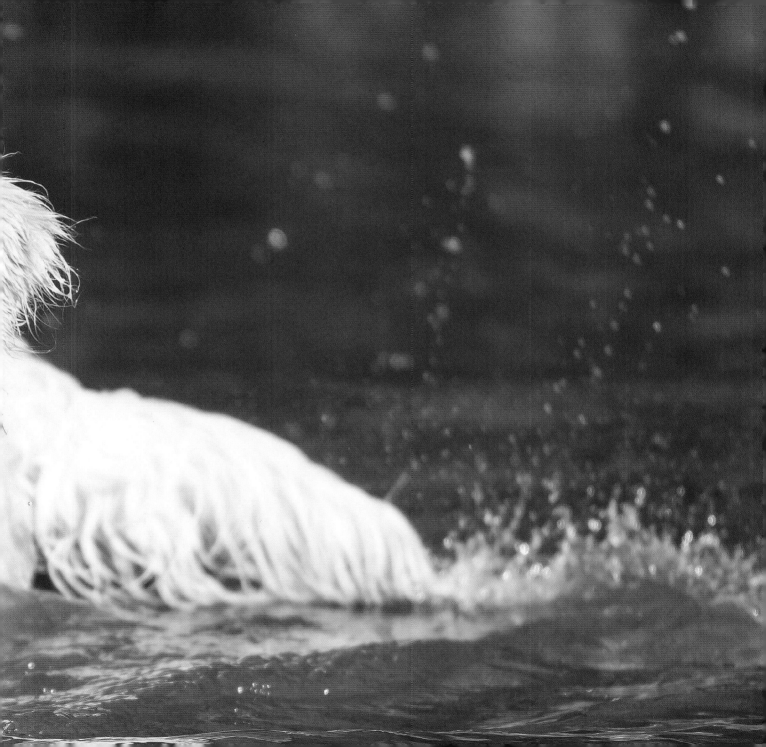

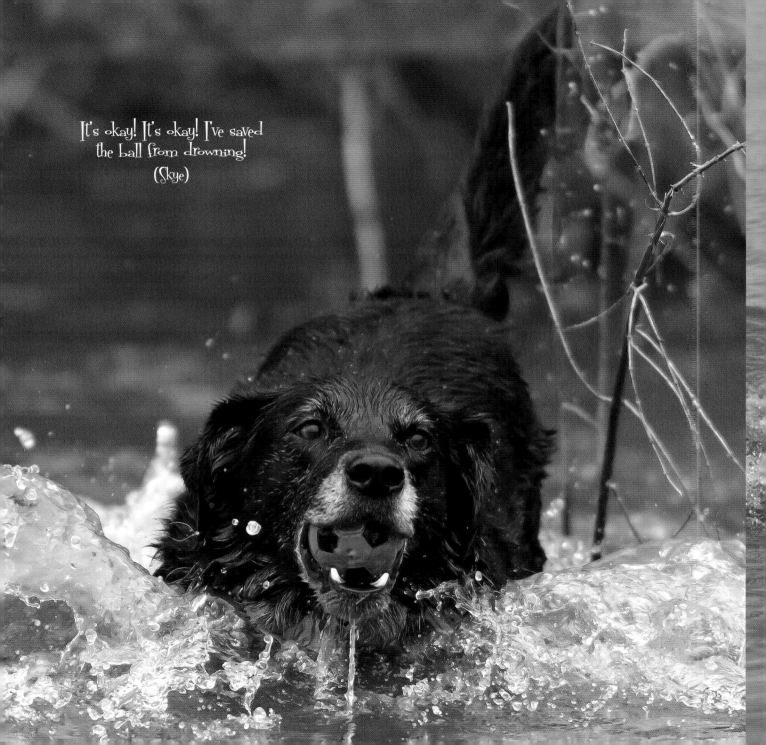

It's okay! It's okay! I've saved the ball from drowning!

(Skye)

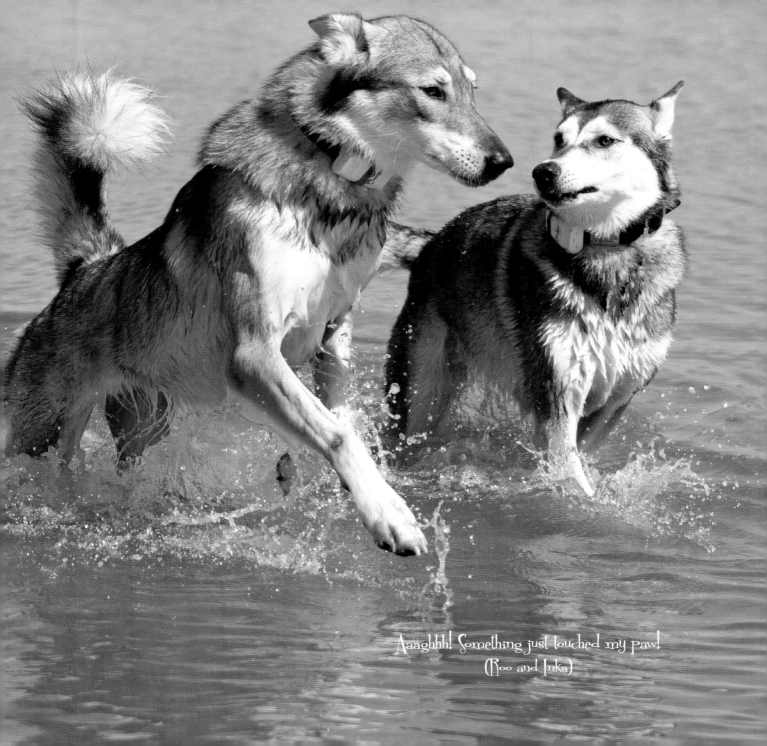

Aaaghhh! Something just touched my paw!
(Roo and Inka)

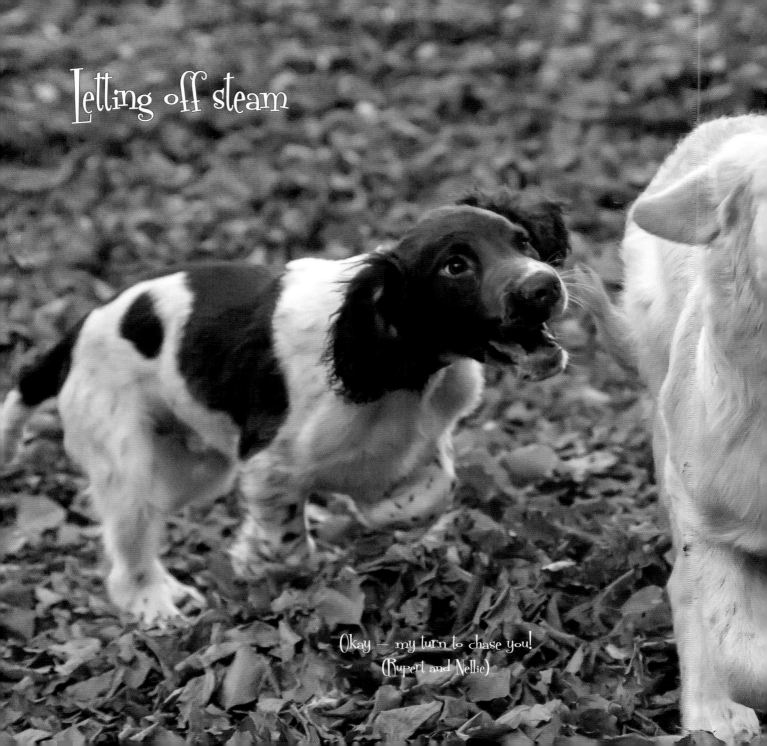

Letting off steam

Okay – my turn to chase you!
(Rupert and Nellie)

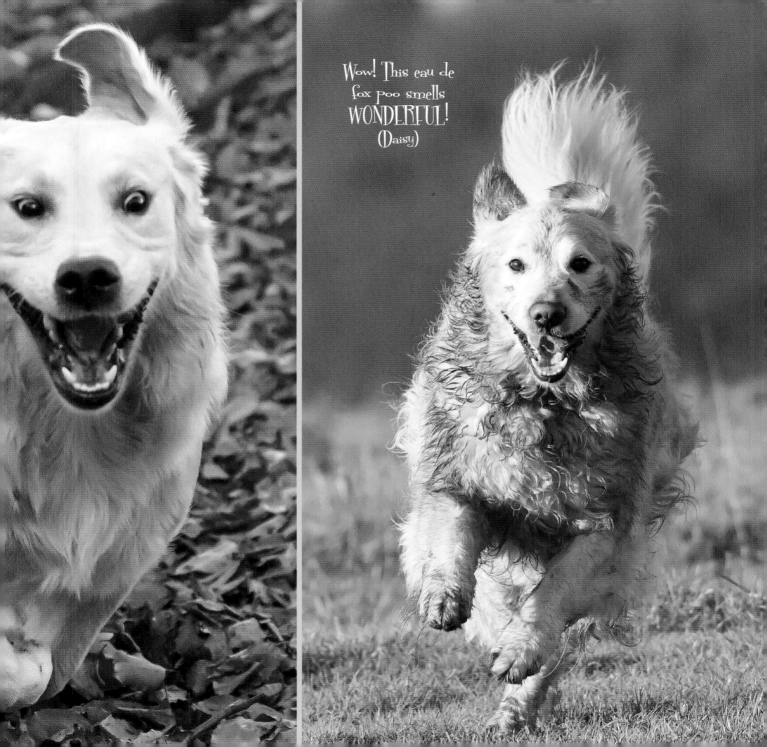

Wow! This eau de fox poo smells WONDERFUL! (Daisy)

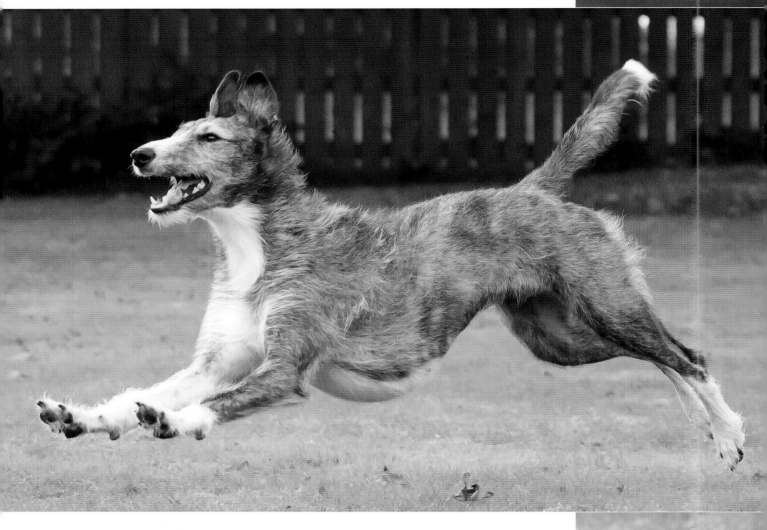

... and my next yoga move will be downward-facing dog ...
(Dora)

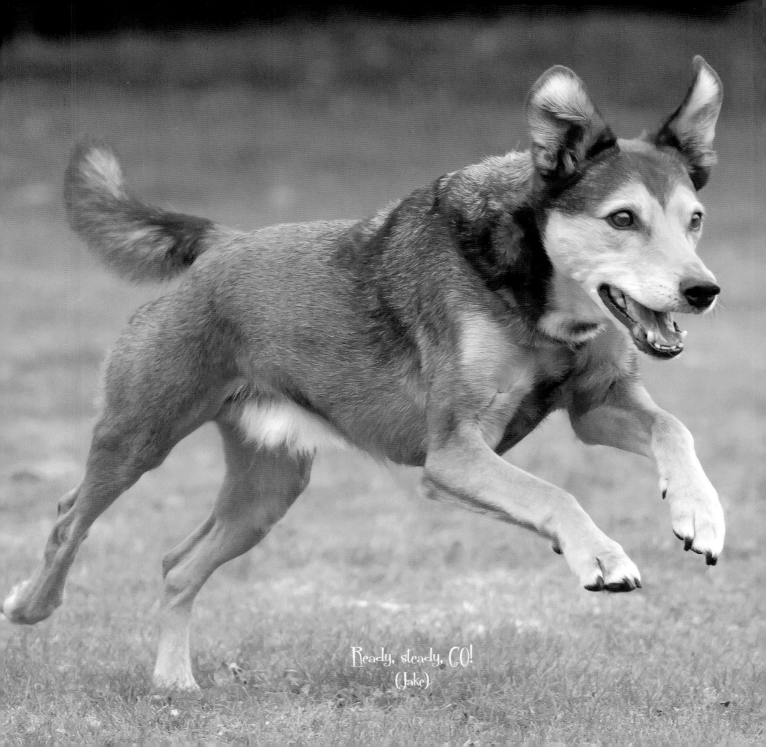

Ready, steady, GO!
(Jake)

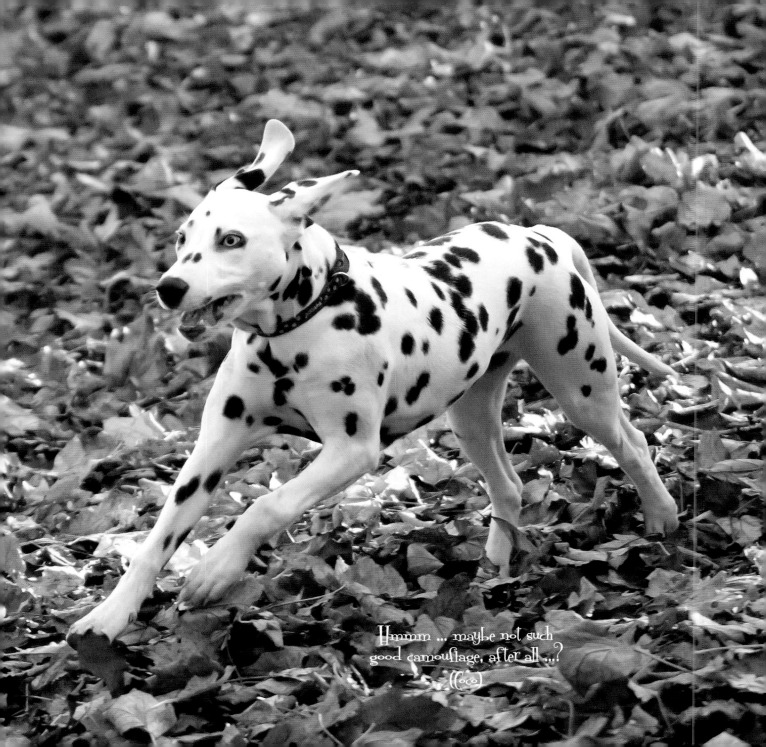

Hmmm ... maybe not such
good camouflage, after all ...?
(Coco)

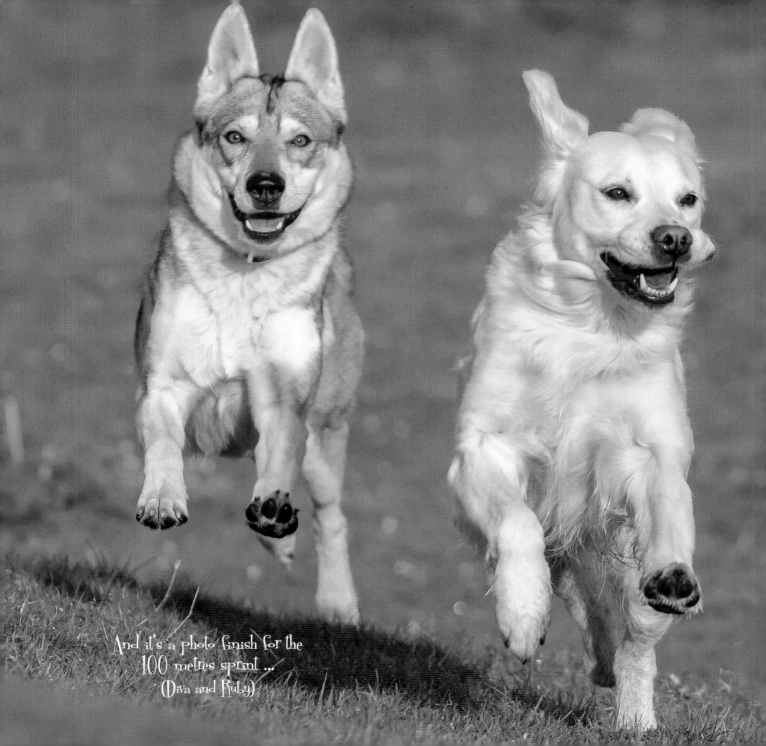

And it's a photo finish for the
100 metres sprint ...
(Diva and Ruby)

Lola — up to her 'ears' in it!
(Lola)

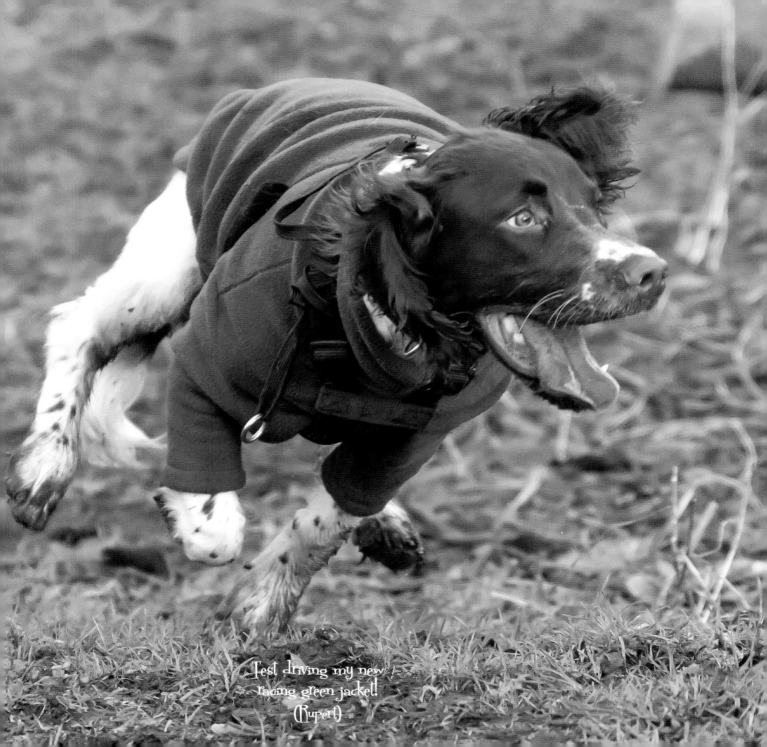

Test driving my new
racing green jacket!
(Rupert)

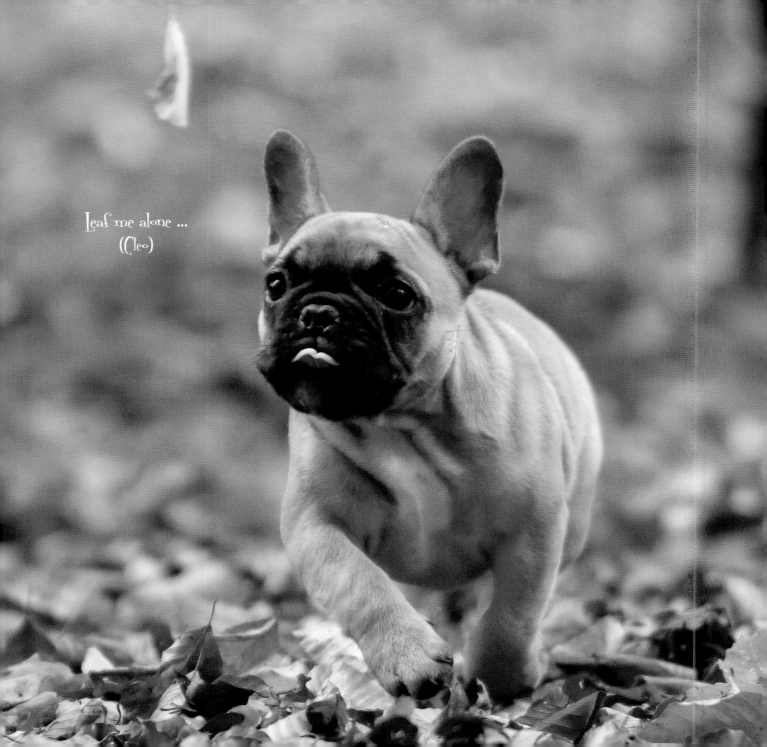

Leaf me alone ...
(Cleo)

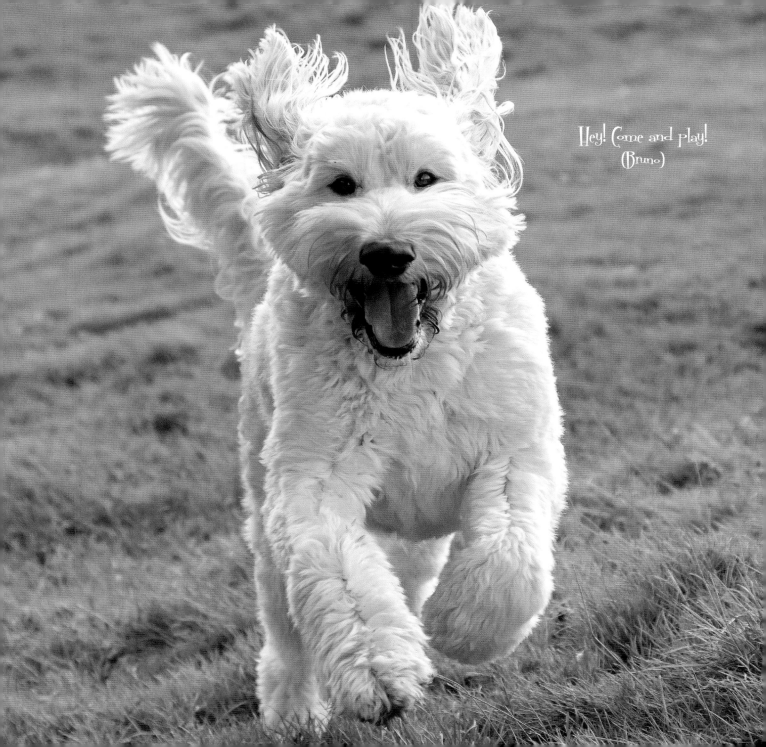

Hey! Come and play!
(Bruno)

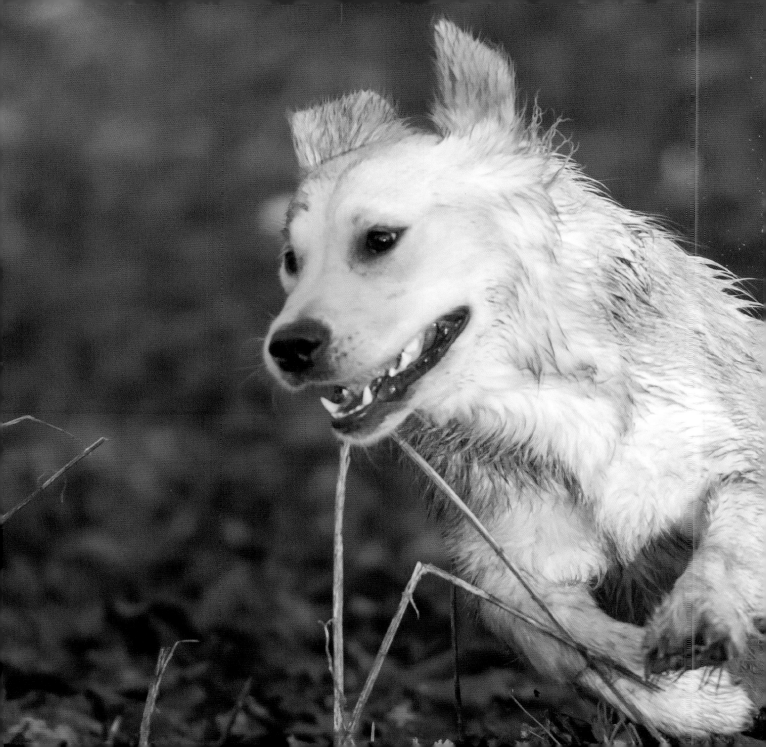

Look out, Rossi: I'm really
getting my knee down!

(Nellie)

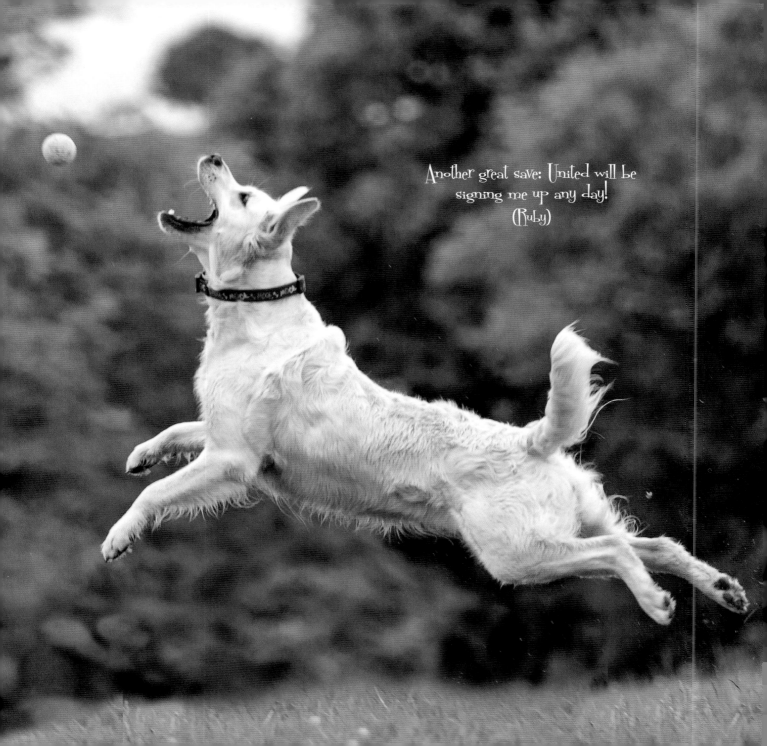

Another great save: United will be
signing me up any day!
(Ruby)

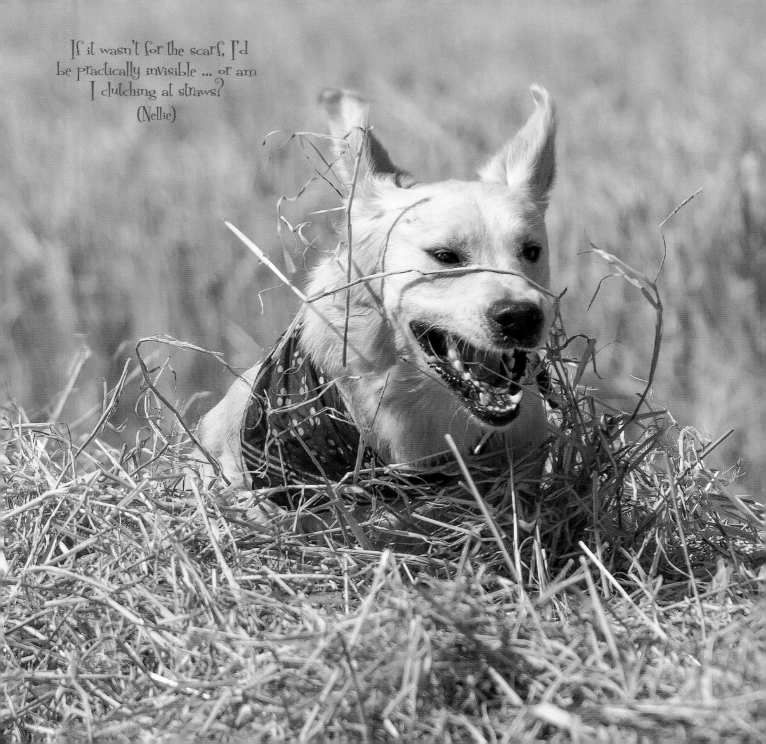

If it wasn't for the scarf, I'd
be practically invisible ... or am
I clutching at straws?
(Nellie)

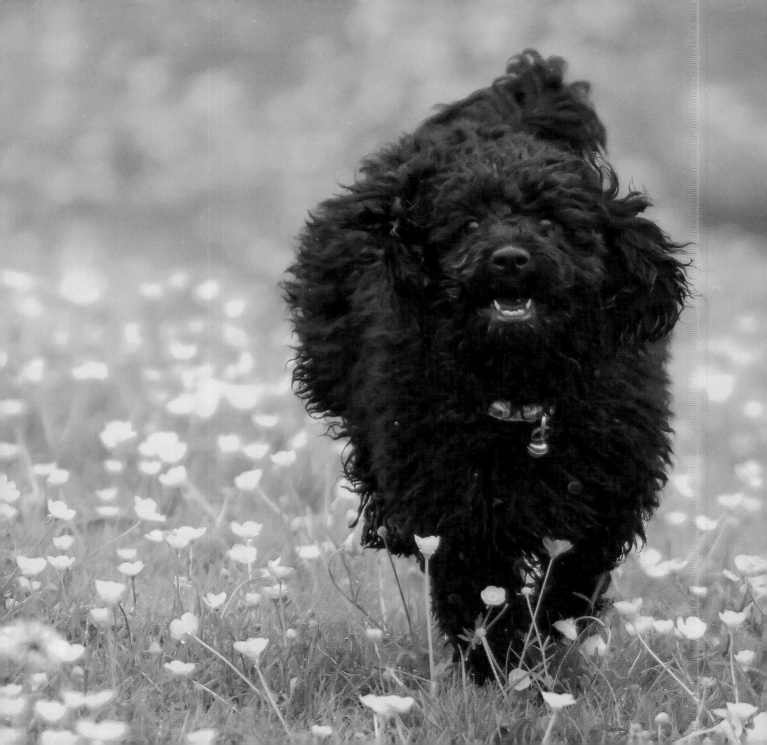

Ooooh! Is this the Yellow Brick Road ...?
(Trevor)

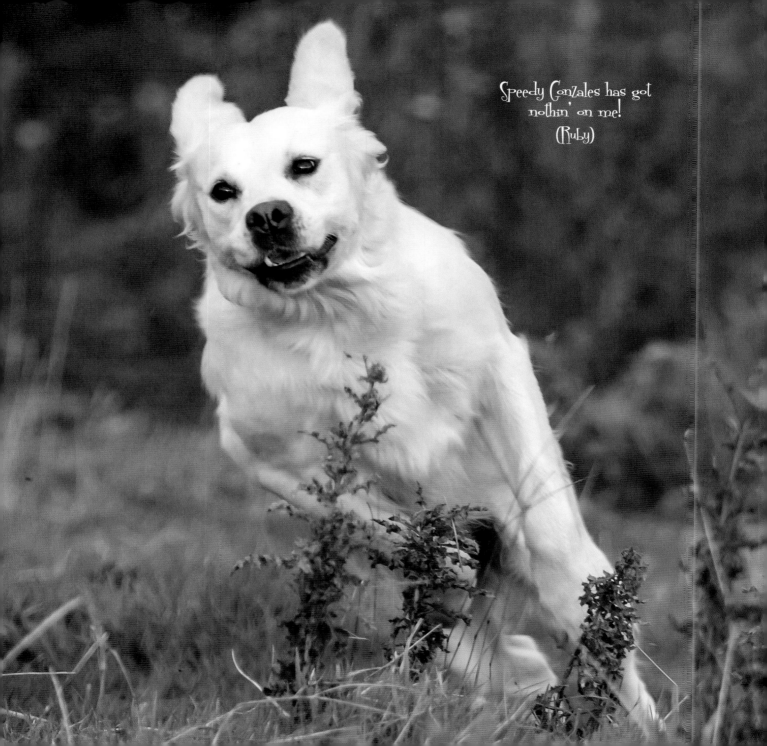

Speedy Gonzales has got
nothin' on me!

(Ruby)

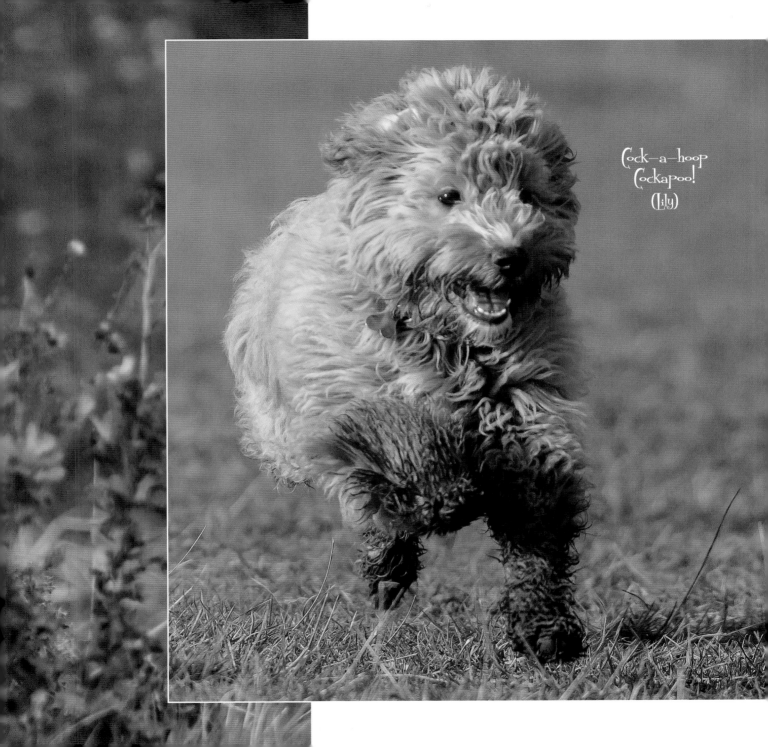

Cock-a-hoop
Cockapoo!
(Lily)

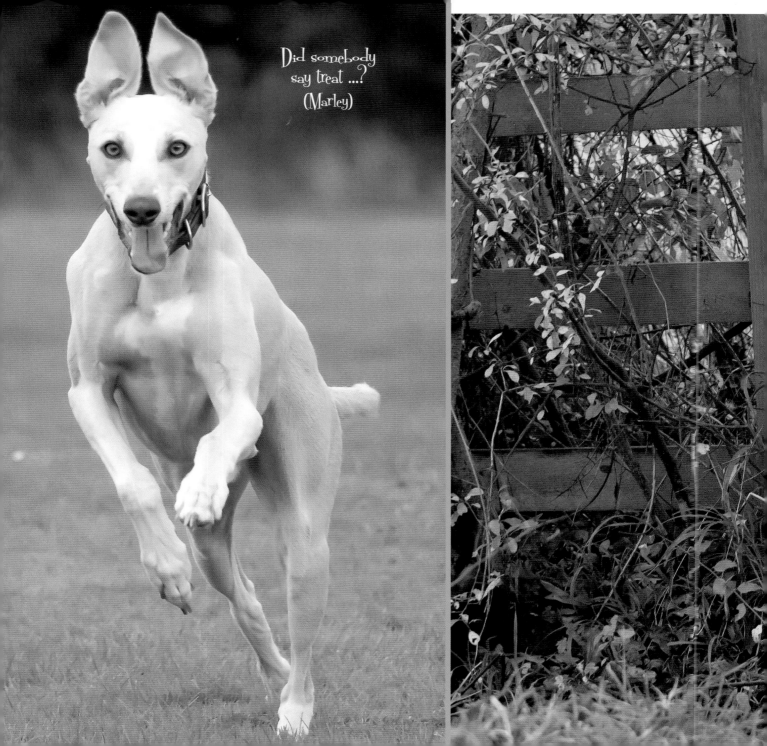

Did somebody
say treat ...?
(Marley)

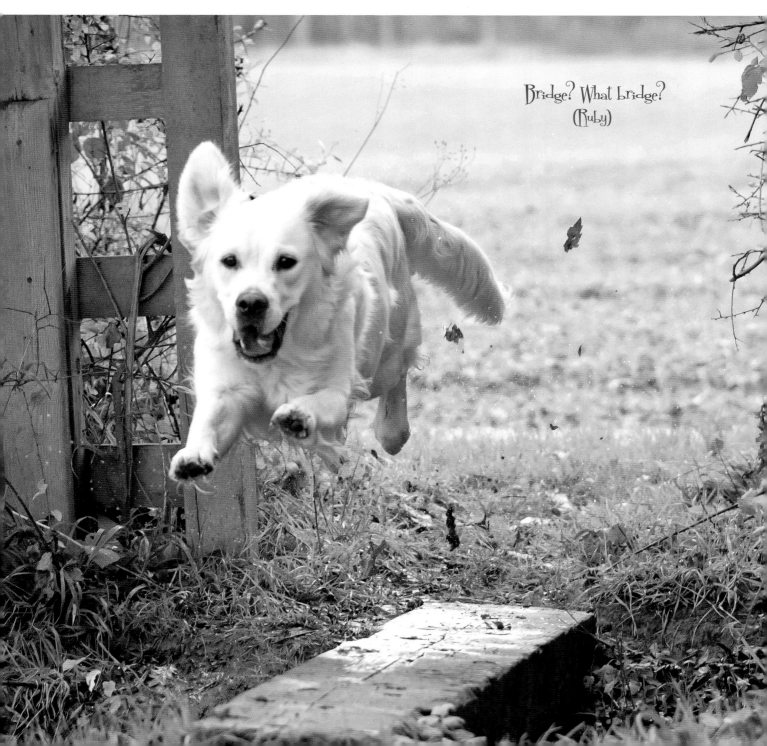

Bridge? What bridge?
(Ruby)

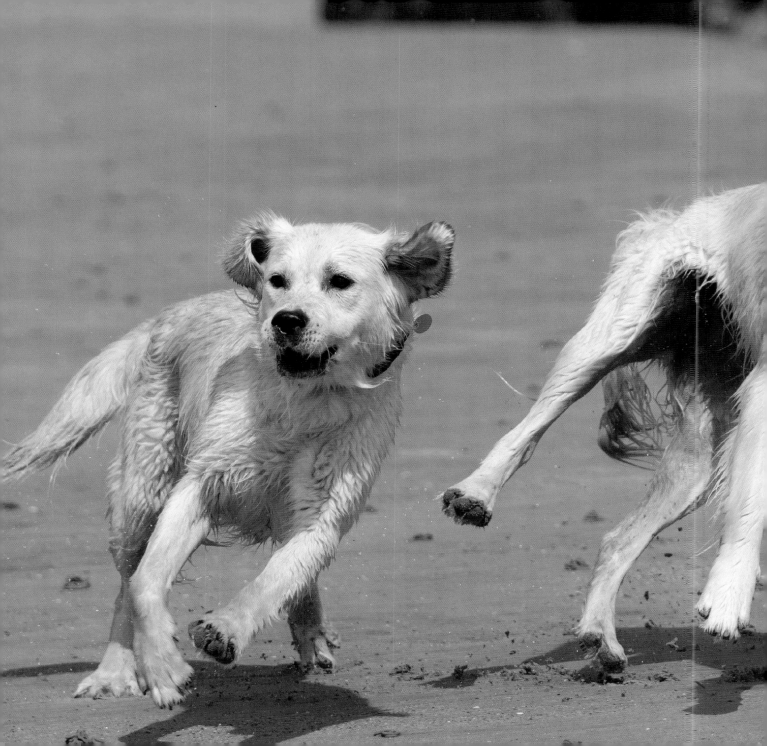

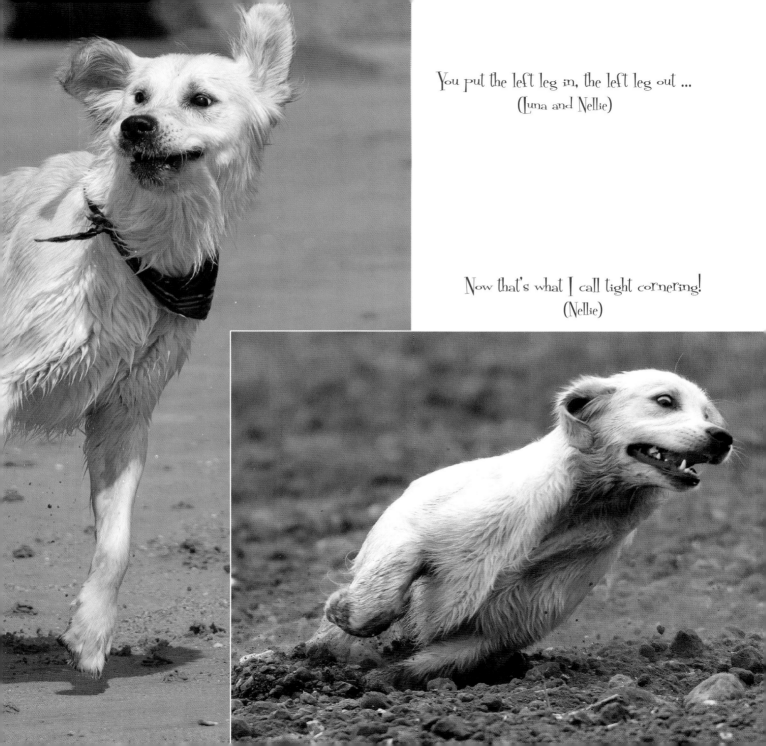

You put the left leg in, the left leg out ...
(Luna and Nellie)

Now that's what I call tight cornering!
(Nellie)

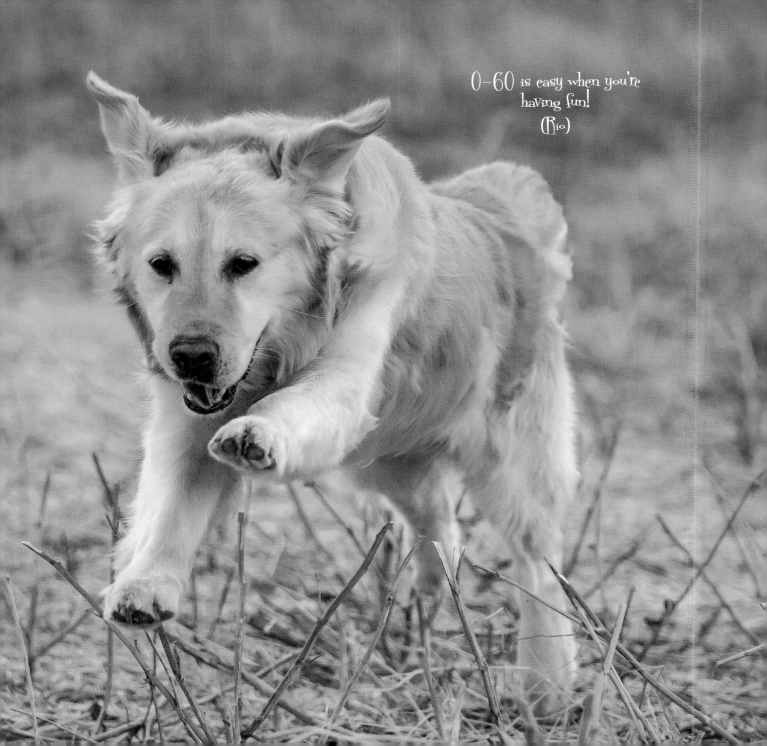

0-60 is easy when you're having fun! (Rio)

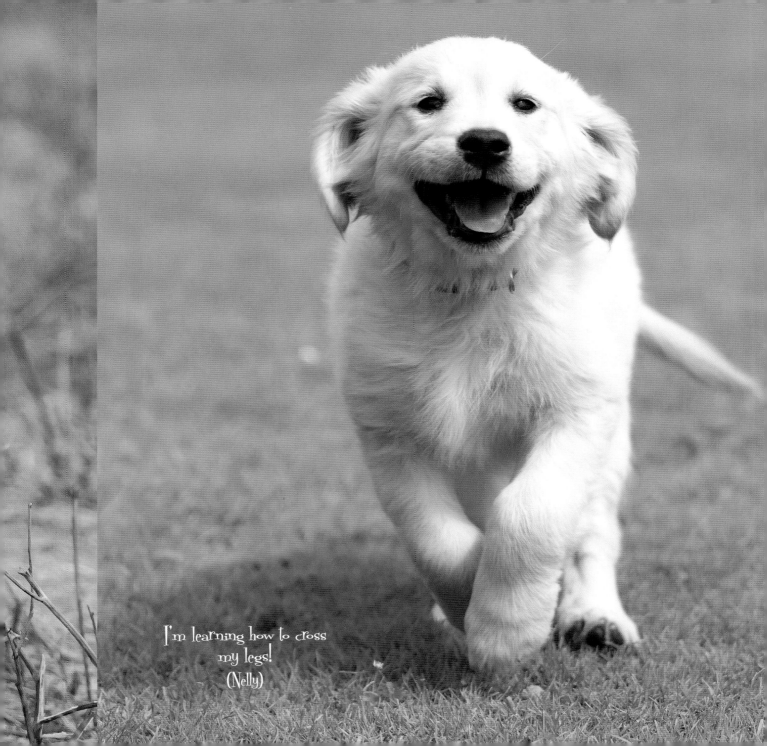

I'm learning how to cross
my legs!
(Nelly)

Poseurs

Yeah, okay: I think you've
got my best side ...
(Neddie)

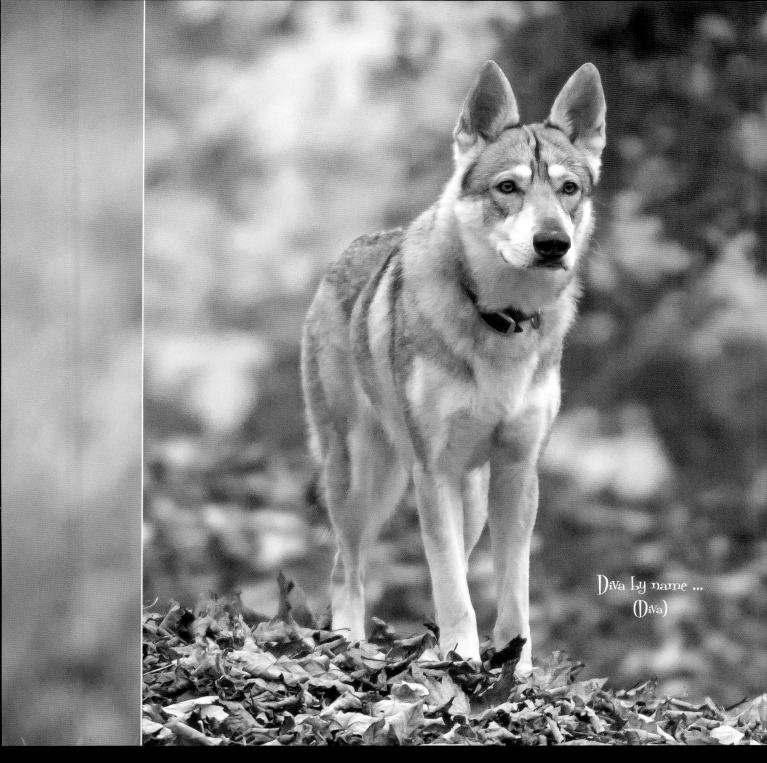

Diva by name ...
(Diva)

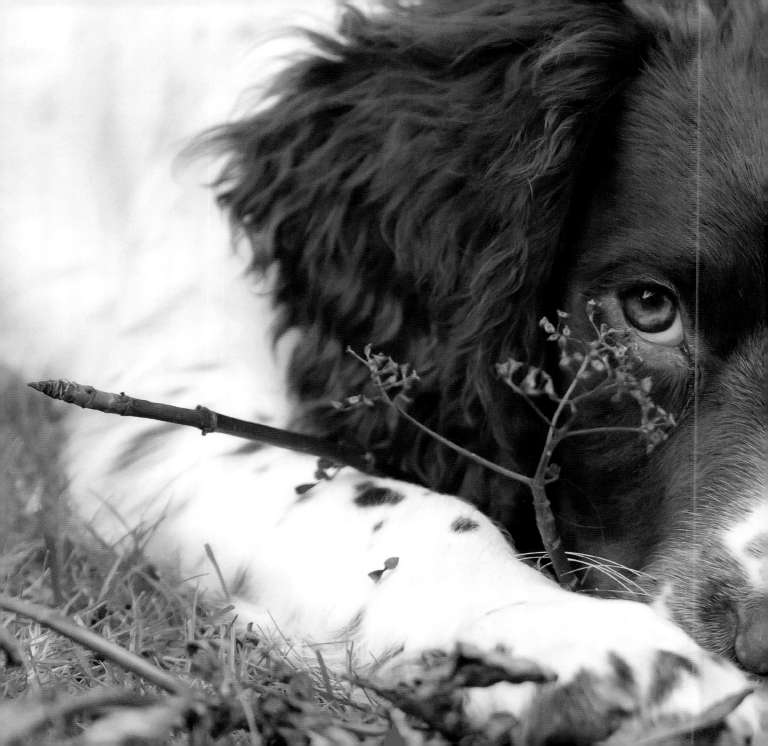

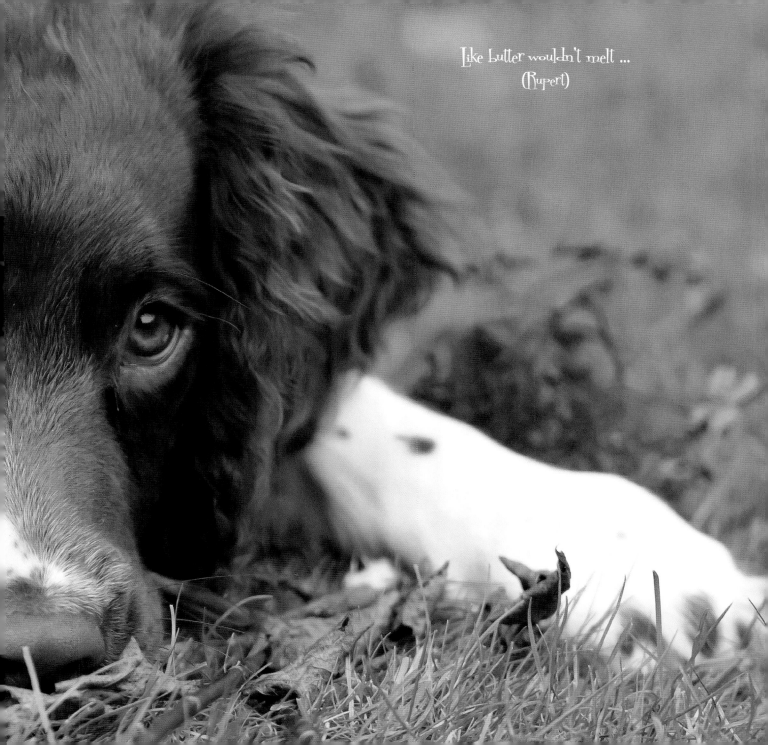

Like butter wouldn't melt ...
(Rupert)

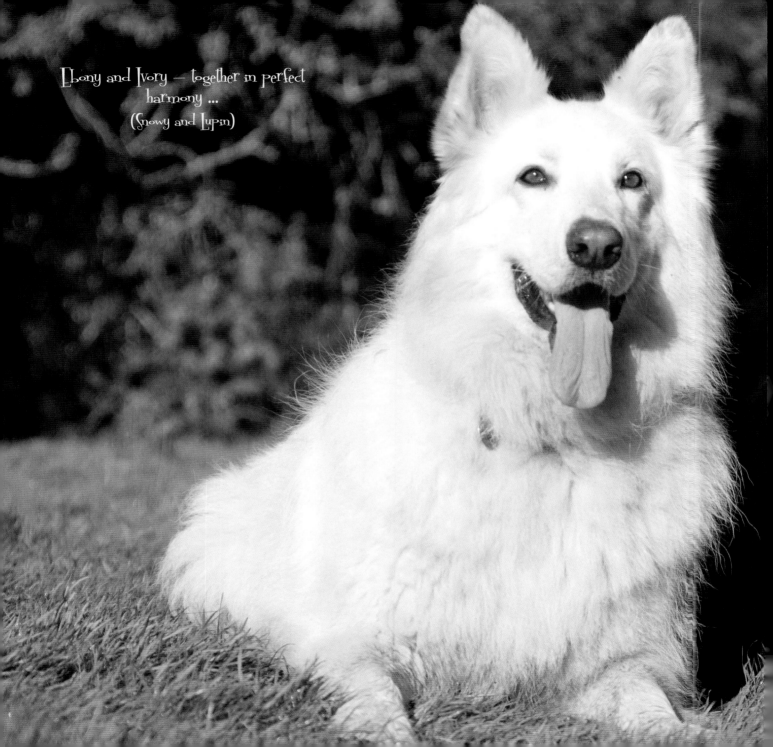

Ebony and Ivory – together in perfect
harmony ...
(Snowy and Lupin)

Just leafing about ...
(Teddy and Bumble)

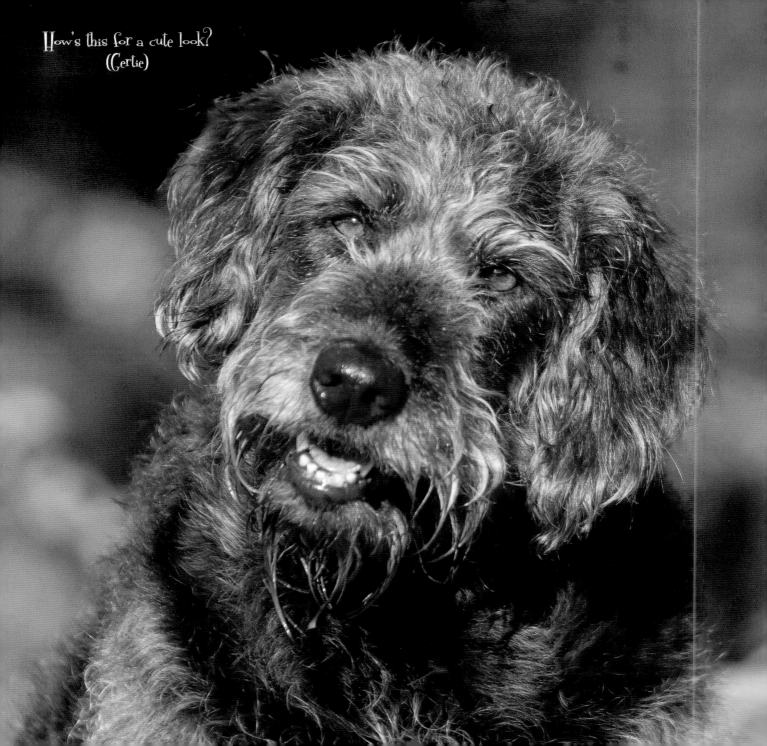

How's this for a cute look?
(Gertie)

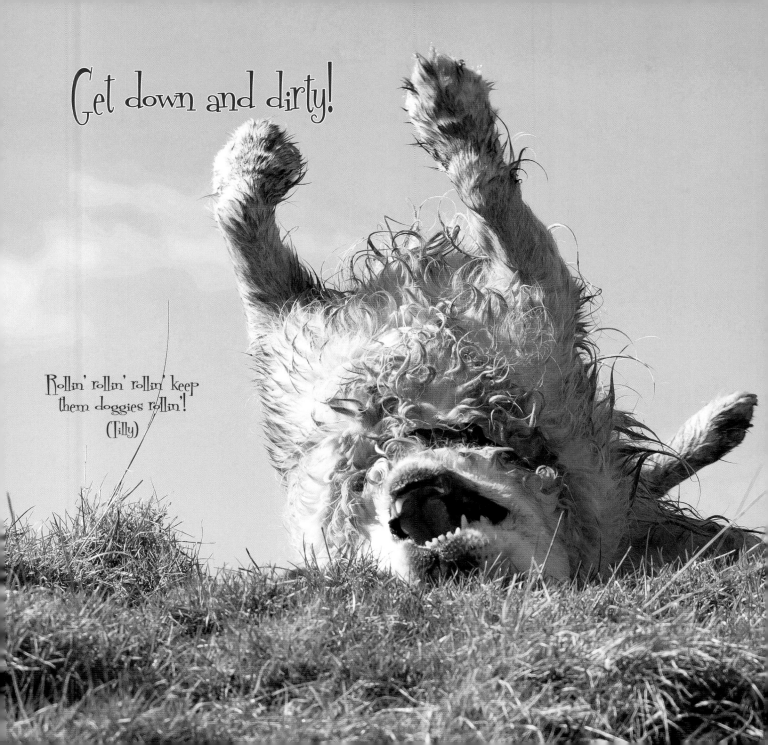

Get down and dirty!

Rollin' rollin' rollin' keep
them doggies rollin'!
(Tilly)

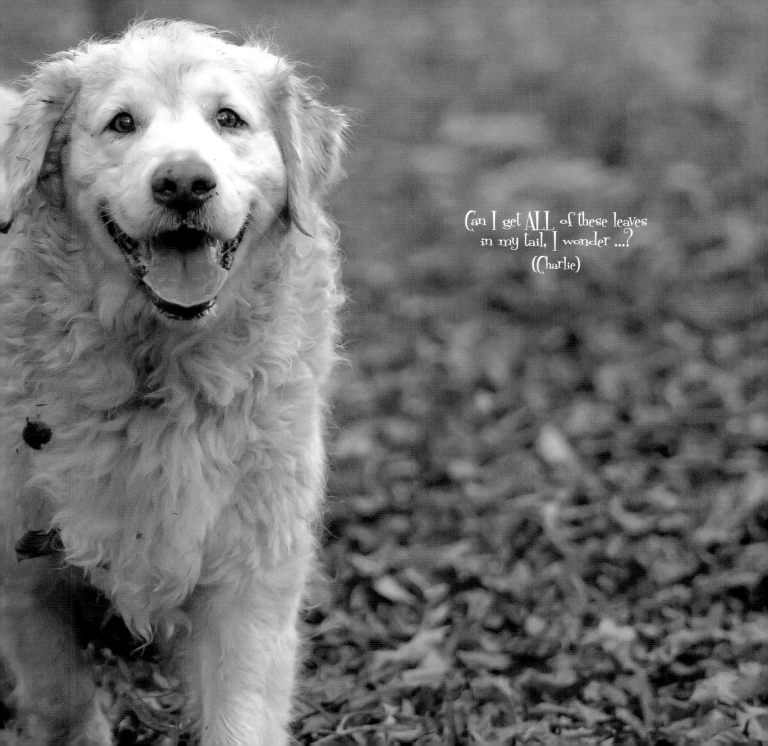

Can I get ALL of these leaves in my tail, I wonder ...?

(Charlie)

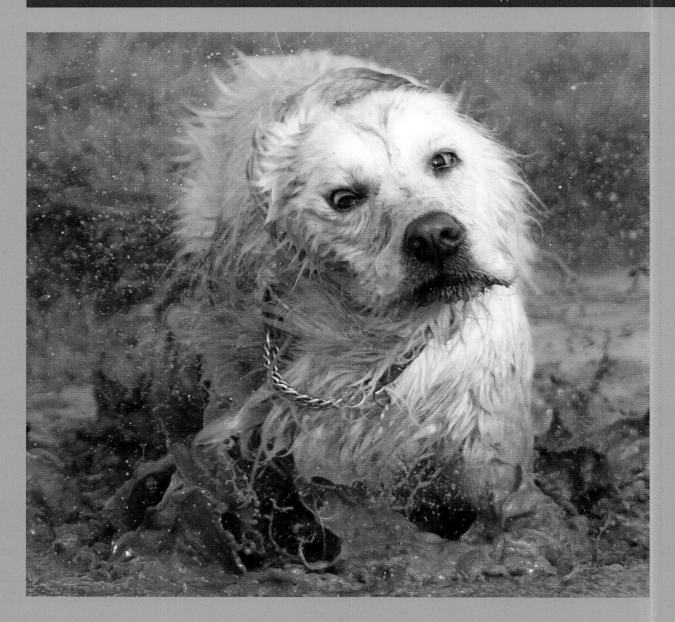

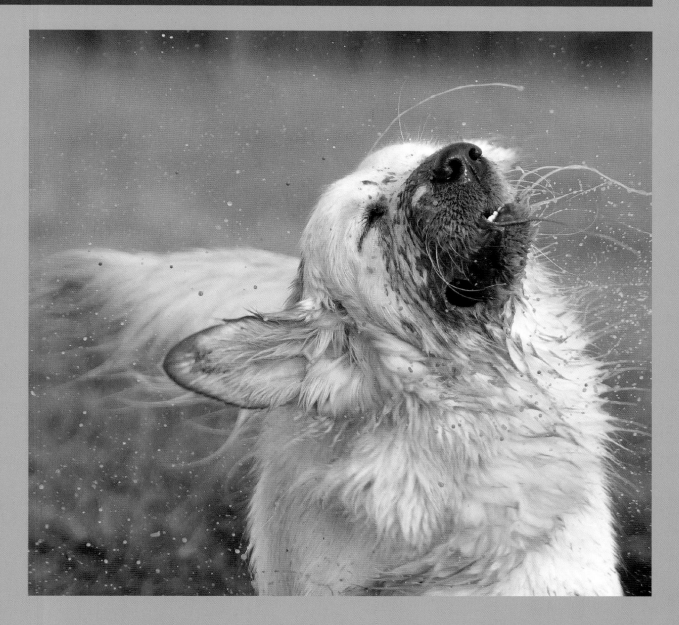

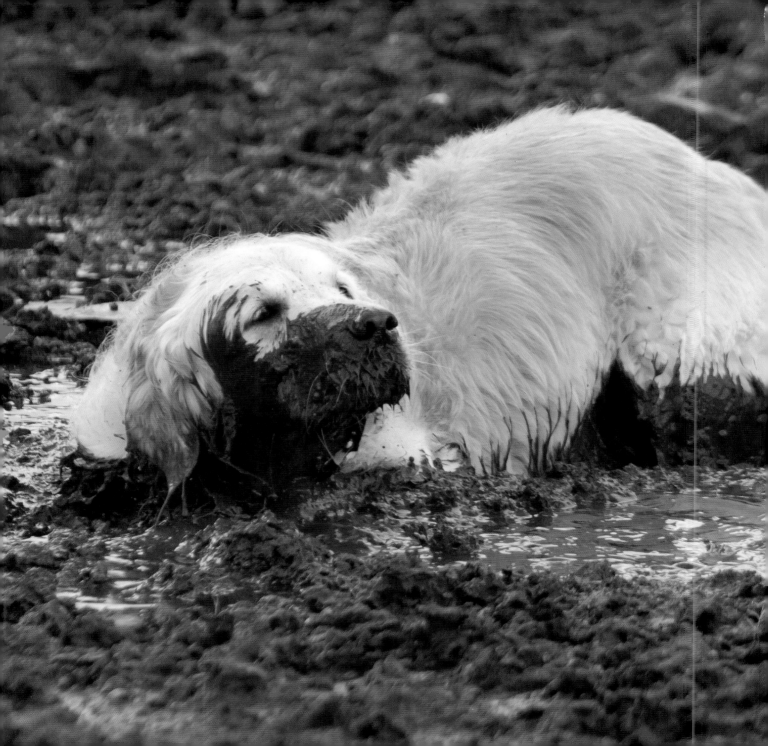

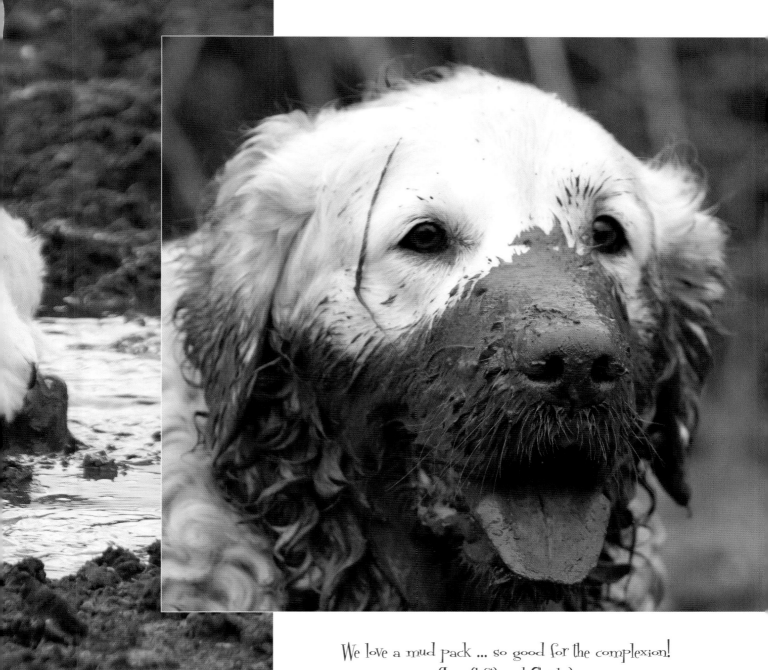

We love a mud pack ... so good for the complexion!
(Luce (left) and Charlie)

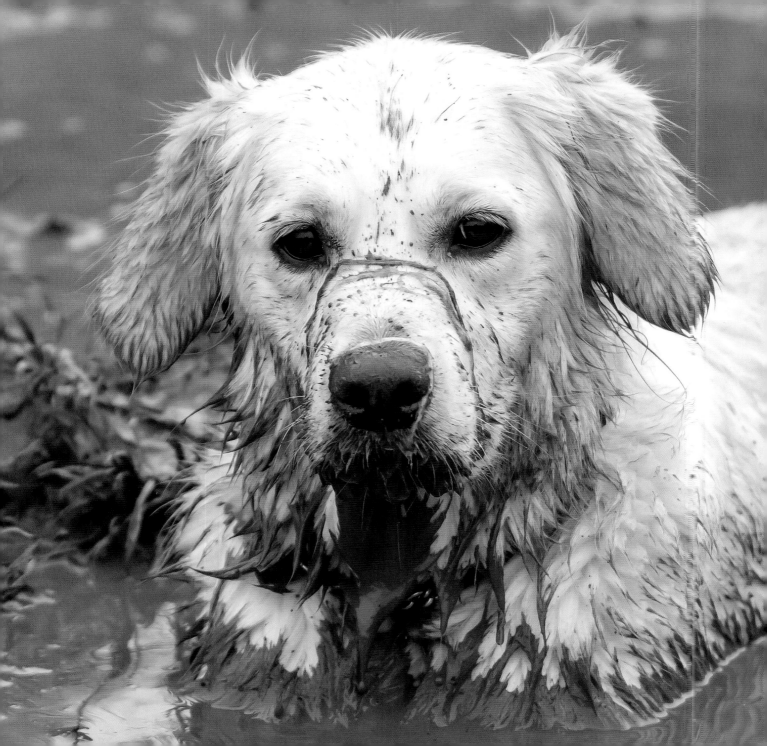

So, I won't be
needing any
more baths at the
groomer's: this one
is MUCH nicer!
(Xana)

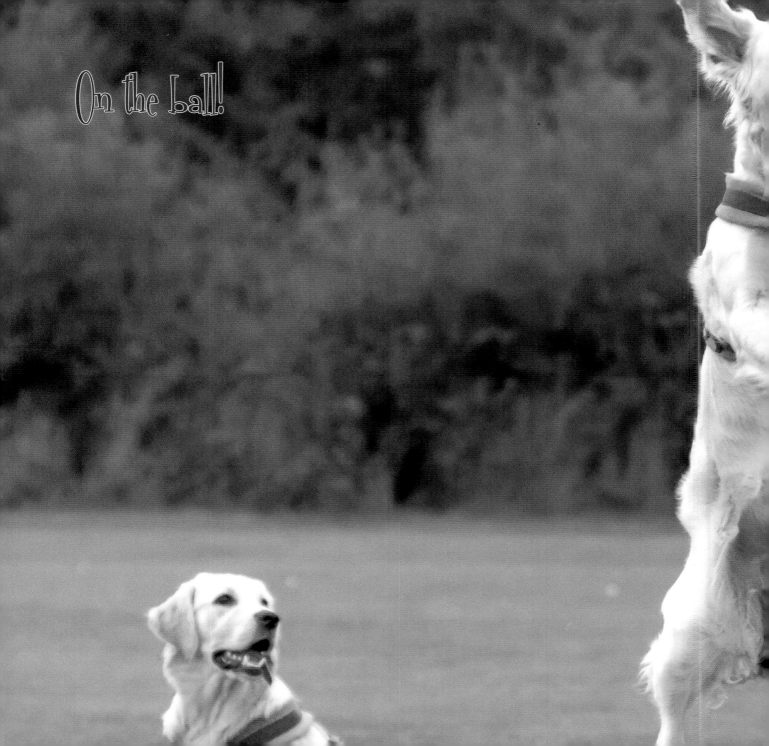

On the ball!

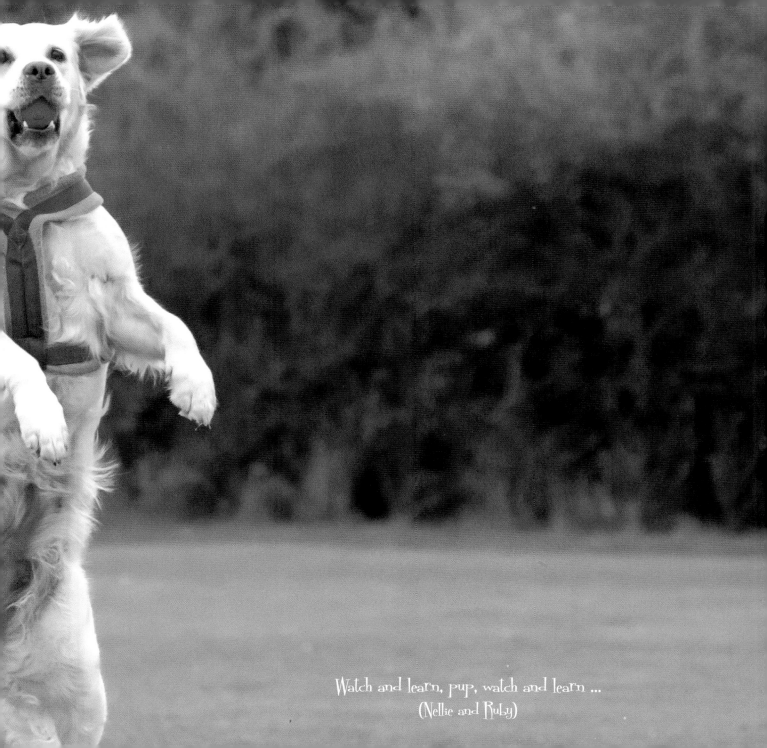

Watch and learn, pup, watch and learn ...
(Nellie and Ruby)

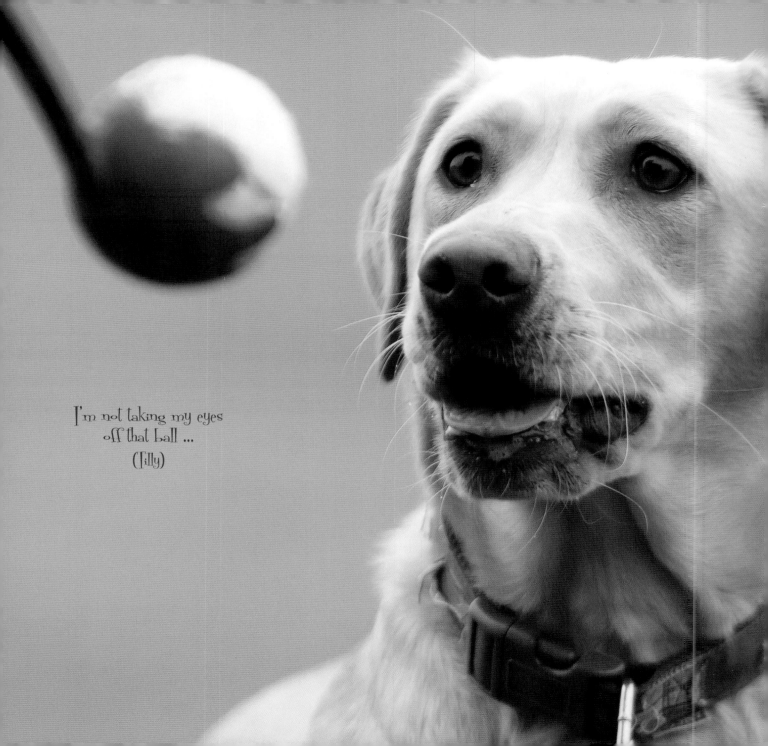

I'm not taking my eyes
off that ball ...
(Tilly)

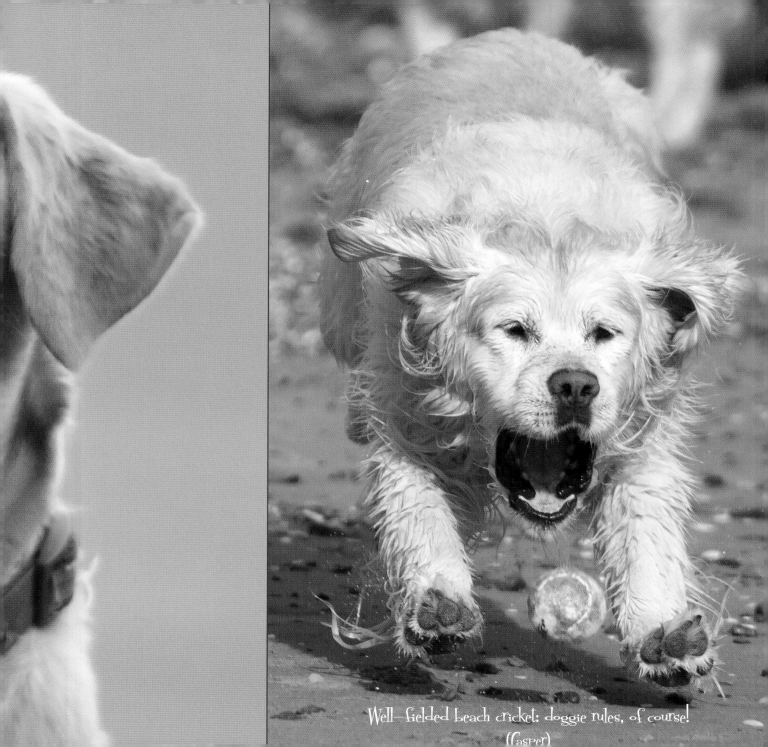

Well-fielded beach cricket: doggie rules, of course!
(Casper)

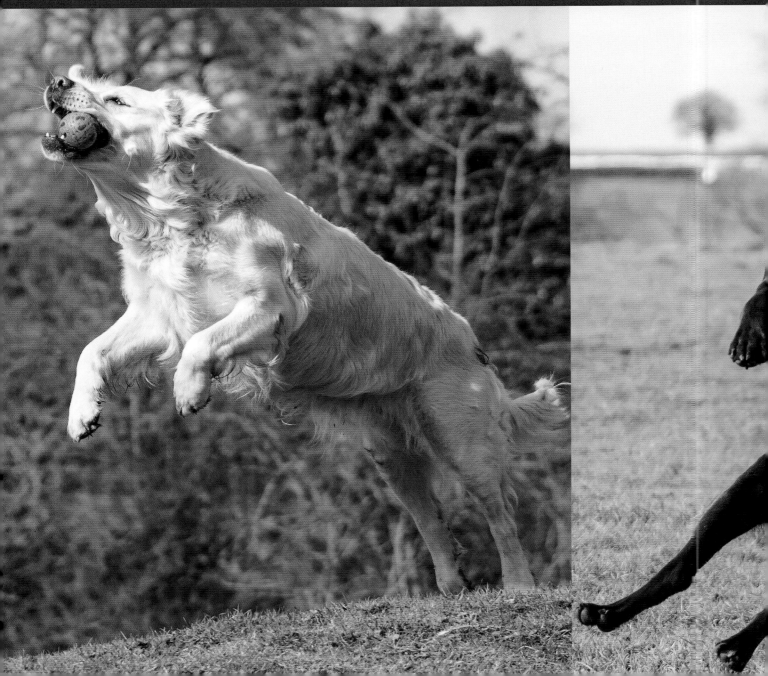

A great turnout for the Rover FC goalkeeper trials: saved, saved, missed!
(Ruby and Poppy)

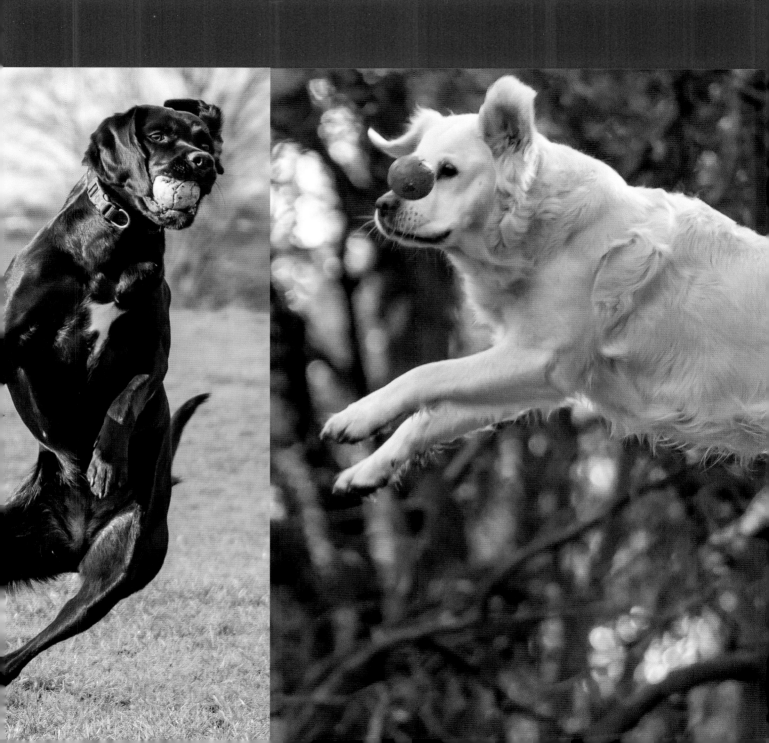

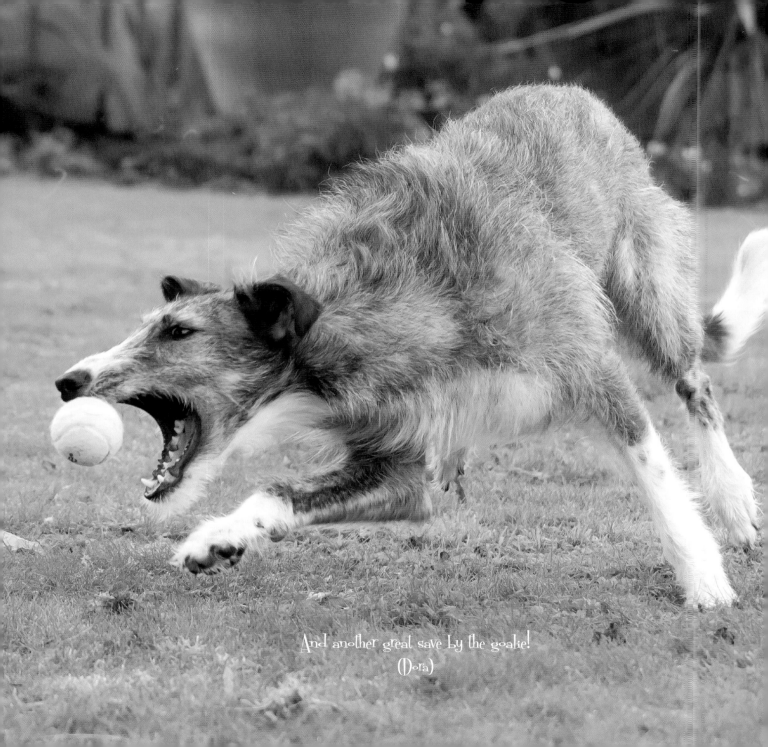

And another great save by the goalie!
(Dora)

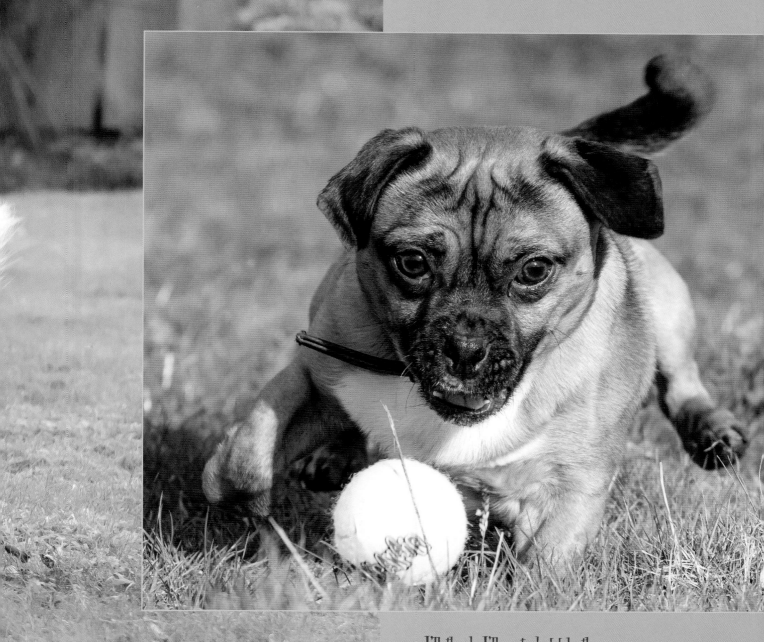

I'll think I'll just dribble this one ...
(Stanley)

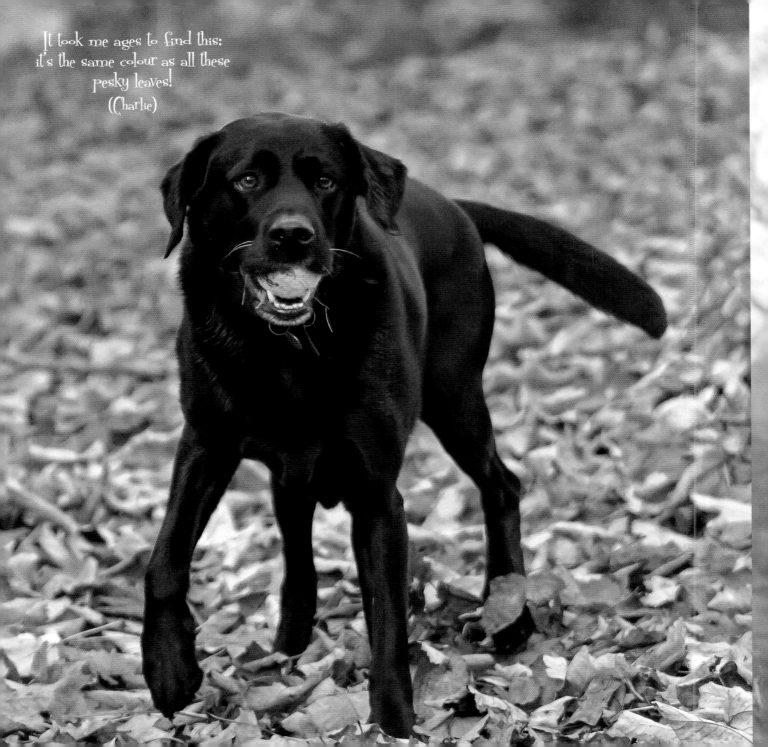

It took me ages to find this:
it's the same colour as all these
pesky leaves!
(Charlie)

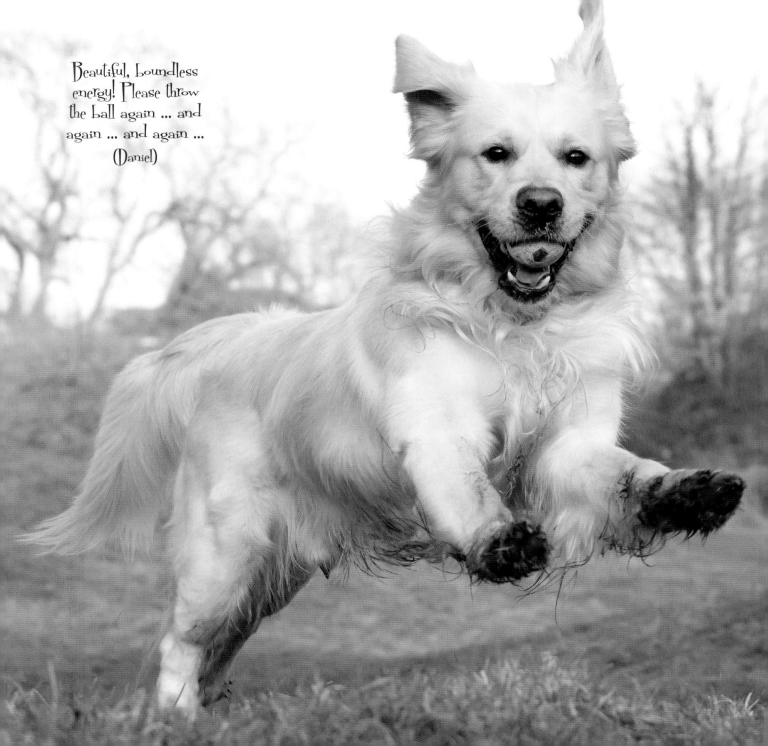

Beautiful, boundless
energy! Please throw
the ball again ... and
again ... and again ...
(Daniel)

Tribute to Tilly

A major inspiration for this work was my Golden Retriever, Tilly, who displayed most of the canine attributes showcased in this book throughout her life. Tilly was the most obstinate, opinionated Golden Retriever you could ever encounter, but her zest for life was unrivalled.

Disproving the theory that dogs cannot differentiate between colours, her pink ball was an essential accessory on our daily walks. Any attempted substitution for different coloured balls was met with great disdain, and replacement balls for the multitude lost in mud, the sea and down rabbit holes arrived from her international fan club. Any balls of the wrong weight, texture or colour were scornfully rejected and never touched again.

As far as Tilly was concerned, people existed to throw her ball for her. She instinctively knew when outings were drawing to a close, and wandered off to find new people who might be prepared to do this for her. She gatecrashed picnics, disturbed orienteers' map reading, and wandered on to golf greens to lob her ball at golfers lining up for their perfect shots. Those not quick enough to realise their true role in life were treated to incessant barking until they threw the ball for Tilly ... again and again ... until she could be persuaded to leave.

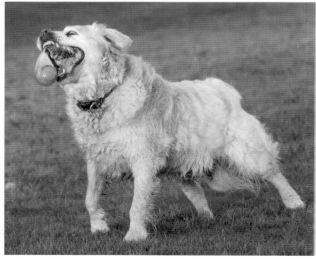

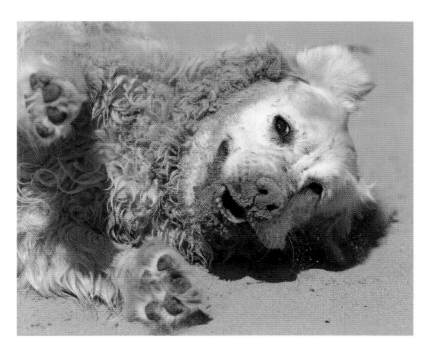

Tilly was able to detect water and mud long before it was visible. Her nose would quiver, her head would lift, and her pace increase. Nothing and nobody could deter her from her quest to find the source, with fresh-running water, muddy streams, and stagnant mud all equally attractive and eminently suitable for wallowing in.

Risk assessment and health and safety considerations did not feature on Tilly's radar, as she immersed herself in her chosen mud or water hole to await rescue. These rescues included a river running through a steep ravine, a holiday cottage swimming pool (with the owners living on-site), cow troughs when she became less agile, and even high-sided canals.

Although many people loved Tilly, she was extremely discerning in her choice of friends. She adored small children, who were able to love and cuddle her with impunity. If she took a dislike to an adult, though, nothing would change her initial impression, warning growls greeting anyone who invaded her personal space. Approval from Tilly was a rare honour indeed, but, once Tilly had accepted someone, her devotion and loyalty were unrivalled.

When Tilly lost interest in going out with her ball we knew it was time for her to leave us. This book is for you, Tilly: your memory lives on.

Cheryl Murphy

Meet the Cast

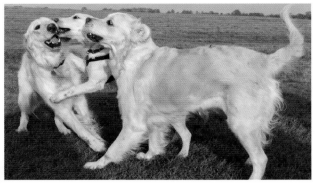

Amy and Daisy (with Ruby)

Amy: Golden Retriever; 4 years old: a loyal, calm, gentle girl with many friends

Daisy: Yellow Labrador; 6 months old: a lively, sociable girl who loves playing with big dogs

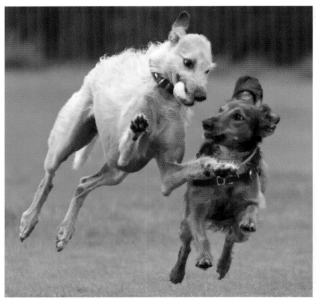

Alfie and Violet

Alfie: 4-year-old rescue Deerhound Lurcher cross: a very vocal boy who loves to zoom around with his doggy pals

Violet: 4-year-old Saluki Springer: will only be separated from her squeaky ball when she's chasing it

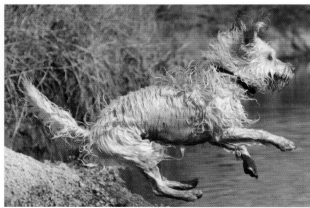

Aston

4-year-old Labradoodle: a cheeky, gentle, intelligent boy who loves ball games and diving

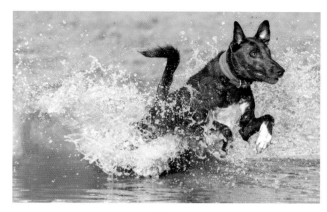

Blue

2-year-old Lurcher: Blue dreams of chasing balls in water

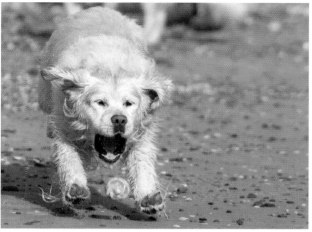

Casper

8-year-old Golden Retriever: when not part of a display team at Crufts, Casper's speciality is drooling on people

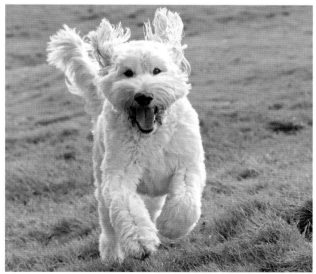

Bruno

Golden Doodle; 19 months old: as daft as a brush with a very big grin. He doesn't care if he plays with dogs or people

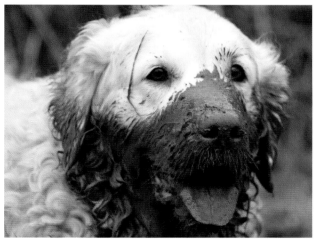

Charlie

Golden Retriever; 12 years old: the master underwear thief and world's best bog snorkeling champion

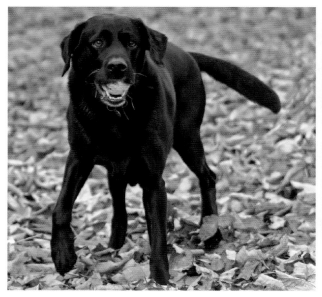

Charlie
Black Labrador; 9 years old: loves nothing more than flying through the water in pursuit of large sticks, and sprawling on a rug hogging the stove

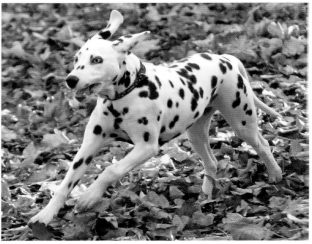

Coco
Dalmation; 18 months old: athough completely deaf, Coco is affectionate and completely crackers

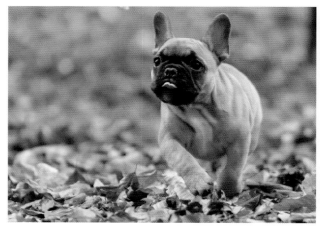

Cleo
French Bulldog; 4 months old: loves peanut butter, shoes, and cuddles

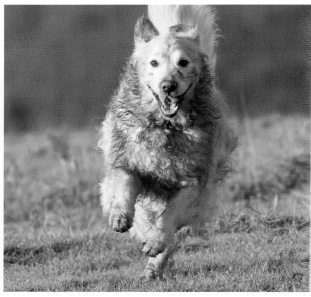

Daisy
Golden Retriever; 8 years old: a totally laidback girl who loves to show off in demo teams

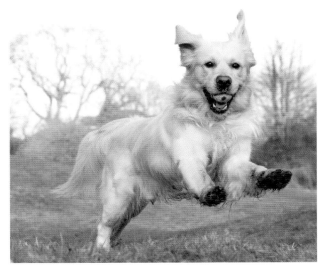

Daniel

5½-year-old Golden Retriever: gentle, happy, placid boy who enjoys flying through the air with his ball

Diva

2-year-old Wolf hybrid: allows her owner a corner of the bed

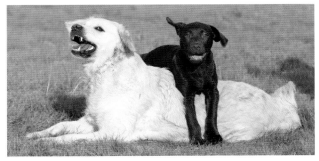

Dexter (with Ruby)

A 6-month-old Chocolate Labrador: very mischievous, loves slippers, flipflops, and leaning on other dogs when he goes out for a walk

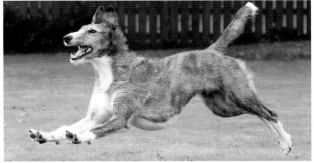

Dora

Rescue Borzoi/Lurcher cross; 2 years old: intelligent, gentle, and respectful girl who loves her new family

Dogs just wanna have FUN!

Gertie
Labradoodle; 7 years old: known to all as the Great Gertsby

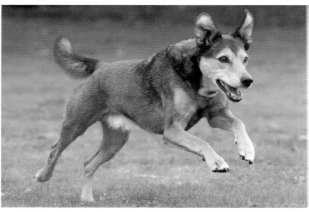

Jake
Crossbreed; 14 years old: the retired Gentleman of the Family

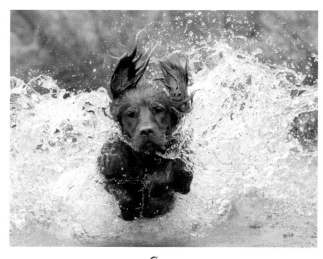

Goose
Working Cocker Spaniel; 2 years old: a high spirited, fearless boy who adores having his ears rubbed

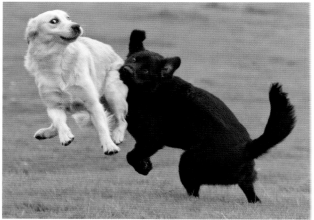

Koby (with Nellie)
Cocker Spaniel/Alaskan Malamute cross; 1 year old: encourages all dogs to play by dancing in front of them

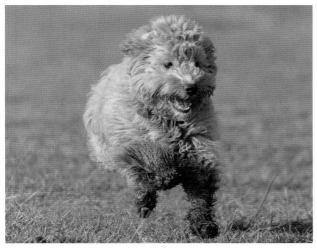

Lily
Cockapoo; 13 months old: completely crackers with a heart of gold

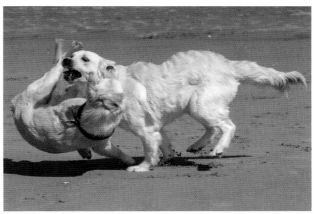

Lottie (with Nellie)
Golden Retriever; 18 months old: the two best things in Lottie's life are chasing squirrels and chewing her dad's slippers

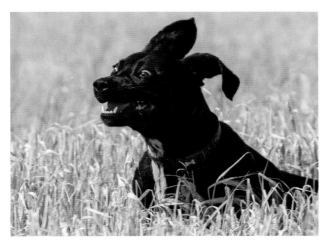

Lola
Springer/Labrador/Ridgeback cross; 2 years old: mad as a box of frogs

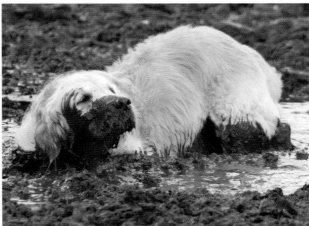

Luce
Golden retriever; 7 years old: energetic, vocal mud magnet

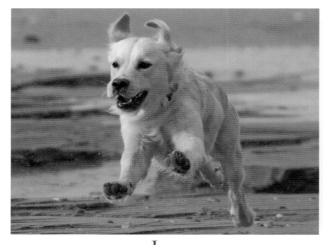

Luna
Golden Retriever; 18 months old, and Nellie's sister: a great conversationalist who loves to express her opinion to passing strangers. Her real talent is in being so lovable

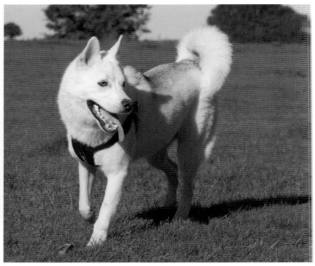

Max
Siberian Husky; 1 year old: energetic, cheeky, lovable hound

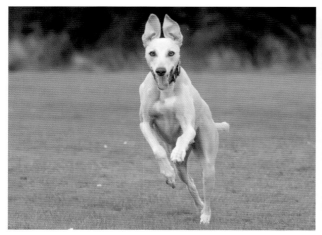

Marley
Lurcher/Greyhound cross; 8 years old: mischievous, lovable rogue adored by everyone

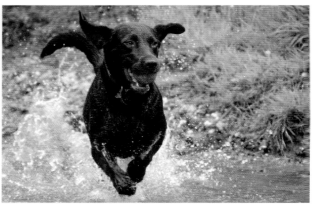

Meg
Chocolate Labrador; 8 years old: known as Nutmeg the Water Baby

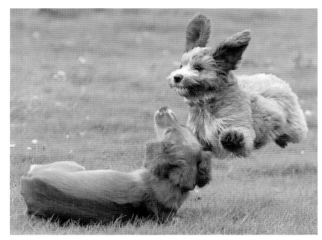

Molly and Margot

Molly: Cocker Spaniel; 6 months old: mischief is her middle name

Margot: Cockapoo; 5 months old: had her owners trained in under three months

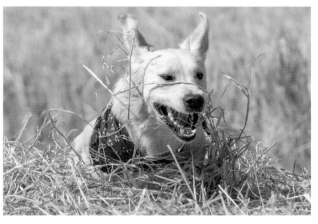

Nellie

Golden Retriever; 18 months old: has unlimited energy and loves everybody

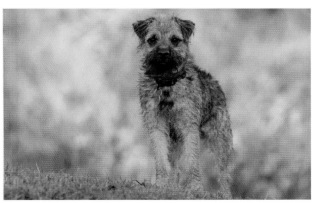

Neddie

Border Terrier; 6 months old: cheeky, bright boy who likes nothing better than a game of tag in the undergrowth

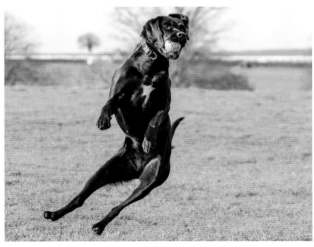

Poppy

Labradoodle; 7 years old: the girl with the waggiest tail, who loves to hurl herself at delivery men

Dogs just wanna have FUN!

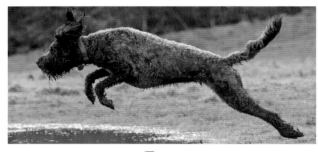

Poppy
Springador; 2 years old: a girl with boundless energy who can read her owners like a book

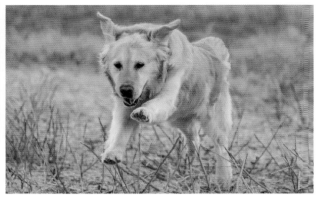

Rio
Golden Retriever; 13 years old: the stature and bearing of a true gent, and a heart as big as the ocean

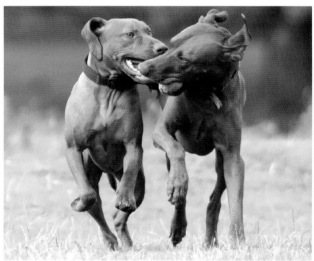

Remus and Lucas
Remus: Rescue Vizsla; 7 years old: lives up to his nickname of Velcro dog

Lucas: Rescue Vizsla; 2 years old: loves cuddles when he is having a rest from learning English words

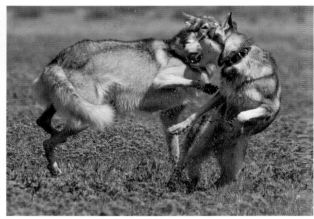

Roo and Inka
Roo: Northern Inuit; 4 years old: a daydreamer without a care in the world

Inka: Nothern Inuit, 5 years old: rather imperious; vocal and commanding

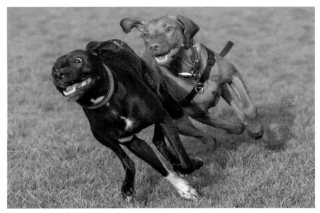

Roxy (with his friend)
Black Hungarian Vizsla; 2 years old: known as Foxy Roxy, he's full of energy ... but a diva on a rainy day

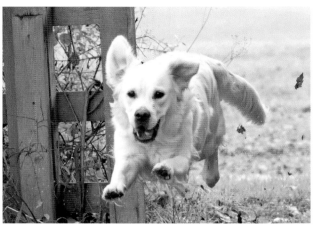

Ruby
Golden Retriever; 5½ years old: a very vocal girl, who's convinced that people are only there to please her

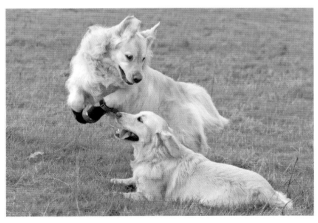

Ruby (with Nellie)
Golden Retriever; 5 years old: known as Ruby Dooby, she's a fun-loving girl with a very big heart, who loves wearing her boots

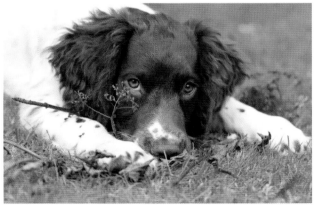

Rupert
English Springer Spaniel; 6 months old: entertaining, lovable boy, known as the Master of Distraction

Dogs just wanna have FUN!

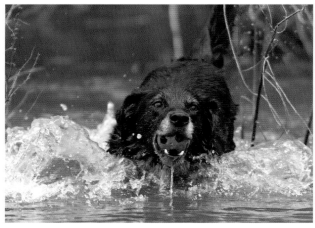

Skye
Collie cross; 9 years old: loves to round up everyone when she isn't chasing her ball

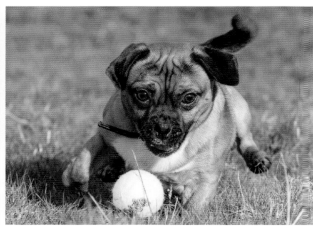

Stanley
Jug (Jack Russell/Pug cross); 18 months old: keeps fit chasing his ball or frisbee, bu would rather be laid on his back, snoring

Snowy and Lupin
Snowy: German Shepherd; 5 years old: dignified elder statesman

Lupin: German Shepherd; 3 years old: crazy, mixed-up kid

Teddy and Bumble
Teddy: Labrador; 2 years old: protector of Bumble, Teddy loves to wash his face and keep him clean

Bumble: Golden Retriever; 7 years old: adores cuddling his toys

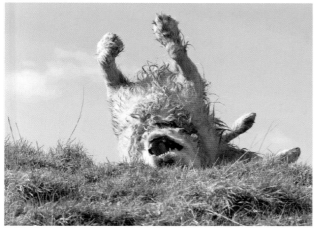

Tilly
Golden Retriever; the stubbornest dog imaginable who made people work for her approval (not very many made the grade!)

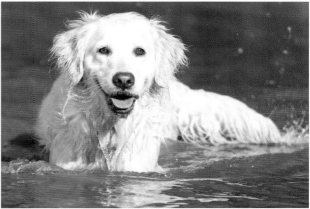

Trevor
Minature Poodle; 4½ months old: the little boy who thinks he's a big boy, with attitude and brains

Tilly
Yellow Labrador; 18 months old: a great show-off who likes to carry three balls at once in her mouth

Wispa
Golden Retriever; 5 years old: this fabulous agility star has the wrong name as she is extremely vocal – and loud with it

Dogs just wanna have FUN!

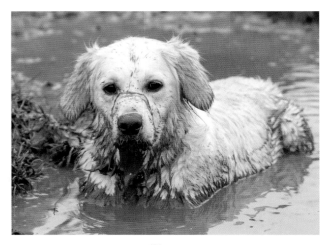

Xana
Golden Retriever; 3 years old: nicknamed
Calamity Jane, as things 'just happen'
when she's about

VISIT HUBBLE AND HATTIE ON THE WEB:
WWW.HUBBLEANDHATTIE.COM · WWW.HUBBLEANDHATTIE.BLOGSPOT.CO.UK · DETAILS OF ALL BOOKS
· SPECIAL OFFERS · NEWSLETTER · NEW BOOK NEWS